ALVIN LANGDON COBURN

Published in
Association with the
International Museum of Photography
at George Eastman House,
Rochester

ALVIN LANGDON COBURN

PHOTOGRAPHS 1900-1924

EDITED BY

KARL STEINORTH

ESSAY BY

NANCY NEWHALL

TEXTS BY

ANTHONY BANNON

KARL STEINORTH

REINHOLD MISSELBECK

MARIANNE FULTON

EDITION STEMMLE

ZURICH NEW YORK

CONTENTS

GEORGE EASTMAN HOUSE is proud to present—first for photokina and then for extended sharing during the Museum's 50th anniversary in year 1999—Alvin Langdon Coburn.

I would like to express my thanks to all who have helped to make this important show possible. My thanks go especially to Professor Dr. Hansgerd Hellenkemper, the Director of the Römisch-Germanisches Museum, who—as in 1996—has invited the George Eastman House to bring a major exhibition to his prestigious institution. I would also like to extend my thanks to Karl Steinorth and Marianne Fulton, who together have planned and organized the show.

Karl Steinorth is our only European trustee and has for many years helped the George Eastman House to bring important exhibitions to Germany. He is a noted author in the field of photography and has curated many photographic exhibitions. He is President of the German Photographic Society, Vice President of the European Society for the History of Photography, and is also a long-standing executive of Kodak in Germany. In 1994 he was awarded the prestigious Hood Medal by the Royal Photographic Society.

Marianne Fulton, chief curator at George Eastman House, and author of *Photojournalism in America*, is the co-curator of the exhibiton. Uppermost in her mind throughout the process has been the audience; in her words, it is important that "the public understands this wonderful man and his delight in life." The vast George Eastman House collections, cared for and interpreted by Ms. Fulton and her talented staff, have unique depth as well as breadth. The approximately 19,227 photographs and negatives by Alvin Langdon Coburn in the Museum's collection have, for example, been given informative breadth by archival holdings that include correspondence with Beaumont Newhall, beginning well before his association with George Eastman House, and continuing through his period at the Museum as curator and director. The correspondence documents Coburn's decision in 1962 to present to the Museum his negatives, prints, letters, scrapbooks, and a bust of himself as a young man, created by his friend, the photographer and Kodak executive in Britain, George Davidson.

In the spring of 1962, Coburn closed a letter to Newhall as follows:

> *"I am 80 years of age in a few days, June 11... but I am still young at heart and life is full of wonder and adventure. Yours ever in the joy of living, Alvin."*

That is the spirit—in Nancy Newhall's words, the "air, atmosphere, its look"—that we sought. Sincere thanks to the team that made it possible.

Anthony Bannon
Director
George Eastman House

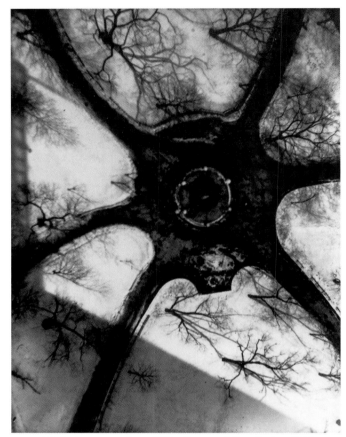

A little-known version of "The Octopus," New York c. 1912

Introduction
Karl Steinorth

ALVIN LANGDON COBURN and his work have fascinated me for more than 35 years. I saw a small selection of his work in the exhibition *Masters of Photography*, shown at photokina 1963. In addition to a superb portrait of the American author Mark Twain, and fascinating pictures of London and Paris, I was particularly impressed by a photograph entitled "The Octopus" (1912). It was a picture of Madison Square in New York City, taken from high above in an adjacent skyscraper. After a winter snowfall, the paths in that square stood out clearly, forming an abstract graphic pattern—indeed comparable to an octopus and its many tentacles.

Kodak researcher Dr. Walter Clark joined me on a walk through the photographic exhibitions at photokina. He told me that in 1962 George Eastman House had published a portfolio of 16 Coburn photographs with an interesting introduction. A short time later, Dr. Clark sent me a copy of that portfolio and offered to introduce me to Beaumont Newhall, the director of George Eastman House, and his wife Nancy Newhall, who had written the Coburn commentary. Thus Coburn was the reason for my visit to George Eastman House and for meeting Beaumont and Nancy Newhall. During our meeting, Beaumont Newhall told me that it was because of the "Octopus" photograph that in 1938 he had contacted Coburn. At the time, Newhall had written to Alvin Langdon Coburn because he wanted to use that photograph in the first edition of his book on the history of photography. It was not easy to find Coburn's address, because Coburn had left the photographic scene to pursue other interests.

During the course of my friendship with Beaumont, the subject of the New Photography in Germany during the twenties became an increasingly frequent topic of our communications. Towards the end of the sixties, Beaumont was preparing an exhibition for the Museum of Modern Art in New York entitled *Photo Eye of the 20s* and he occasionally asked me to follow up on suggestions concerning German photographs and photographic publications. During one of my visits to Rochester he told me that he also planned to include Coburn's "Octopus" in his *Photo Eye of the 20s* exhibition. Ten years before views from above became a commonly used perspective of the New Photography, this key picture by Coburn demonstrated how this can accentuate the abstract forms of streets, squares and buildings.

Beaumont also showed me a small catalogue of a Coburn exhibition at the Goupil Gallery in London, which included five pictures under the heading "New York from its Pinnacles" (1912), which Coburn had taken looking down from skyscrapers. Commenting on these pictures, Coburn wrote that he had chosen this unconventional perspective quite deliberately in order to free himself from the conventions of the time, and that freedom of artistic expression was vital to every form of art. About his photograph "The Thousand Windows" (1912), he wrote that its "almost as phantastic in its perspective as a Cubist fantasy." Elsewhere Coburn wrote that "It was a joy to do something that did not fit in any conventional classification."

Coburn also proved his fondness for experimentation with his "abstract" photographs, his Vortographs. He built himself an apparatus for this purpose, which had three mirrors angled towards each other. He used this camera to photograph Ezra Pound, the spokesman for a movement of abstract painters who called themselves "Vorticists." Coburn displayed these Vortographs in London in 1917, where they attracted considerable controversy. Much later, towards the end of the forties, Nancy Newhall came across this controversy and became so enthusiastic about Coburn's contributions, that she spontaneously sent him a congratulatory letter, even though by then Coburn's text

*Self-portrait by Beaumont Newhall with a view of the exhibition
"Photo Eye of the 20s," Museum of Modern Art, New York 1970*

George Eastman House portfolio of sixteen Coburn photographs. Nancy Newhall had written a detailed biographical introduction for this portfolio. The second important step in the international rediscovery of Coburn was his autobiography, published in England in 1966; it was edited by Helmut Gernsheim and his wife Alison. Later, Gernsheim commented that he had initially declined Coburn's suggestion that Gernsheim should write a monograph about him, citing the outstanding text that Nancy Newhall had already written. But Gernsheim eventually acceded to Coburn's insistence, when the latter agreed to write a biographical text about himself, which then became the basis for the publication.

had been written decades ago. She was fascinated by Coburn the who had been virtually completely forgotten by the world of photography, from which he had totally withdrawn during the twenties. When she and Beaumont Newhall travelled to England in the fall of 1952, she persuaded the editors of the magazine *Modern Photography* to give her the assignment of writing an essay about Coburn. During that trip, the Newhalls visited Coburn and his wife at Rhos-on-Sea in North Wales. They gained an impression of the volume of Coburn's work and, even though the Newhalls were primarily interested in Coburn's Vortographs and his views from above, they were nevertheless astounded by the breadth and depth of Coburn's photographic work. A very warm relationship developed between the Coburn's and the Newhalls right from the very start. "It was as if we had known each other for a long time." This friendship led to the donation of Coburn's work to George Eastman House.

Even though the Royal Photographic Society had already staged a Coburn exhibition in England in 1957, and Reading University had stimulated an interest in Alvin Langdon Coburn's work with an exhibition in January 1962, a truly international rediscovery of this photographer only occurred with the publication in 1962 of a

While I was initially most impressed by Coburn's new way of seeing, two additional aspects of his work deeply impressed me during the period that followed. In 1982 I was very involved with the content of the photokina exhibition *Das gedruckte Foto*. This exhibition was designed to show that the medium of photography was not only a subject for collectors and family albums, but that the printed photograph was of special importance to that medium and to its continued evolution. During the preparatory work on this exhibition we came upon Alvin Langdon Coburn's books—*London, New York, Man of Mark*—and his illustrations for H. G. Wells's book *The Door in the Wall and Other Stories*. Coburn wished as many people as possible to enjoy his extraordinary photographs. To that end, he produced the photogravures for a number of his publications himself (he allegedly printed more than 50,000 photogravures altogether). Coburn took it for granted that a well printed photograph was perfectly comparable to a photographic enlargement. That is why he was always willing to sign his photogravures.

Another example of Coburn's trend-setting work is the photographs that he made for literary works. When the German Society for Photography staged a symposium in the early eighties on the subject *Vom Bild zum Wort—*

vom Wort zum Bild, one of the important topics was how a photograph could accompany a text in an associative manner, i.e. how, unlike conventional illustrations, it constitutes an independent visual contribution to the subject of a text. Coburn's photographs stand alone in just such a way, reinforcing the sentiments of the text with images.

The International Kodak Cultural Program, in association with the Römisch-Germanisches Museum, has invited George Eastman House to present an exhibition in Cologne during photokina 1998. My friends at George Eastman House and I were quick to agree that it should be a retrospective of Coburn's photographic work from the years 1900 to 1924. On one hand, the Coburn collection is an especially important part of George Eastman House collections; on the other, there has never been an exhibition in Europe dedicated exclusively to Coburn (except in the UK), in spite of his importance to photography.

In re-reading the text of Nancy Newhall's original introduction during the preparations for the new exhibition, it became obvious that her text could not be formulated more clearly and more accurately today than it was when she wrote it in 1962. That is why it was selected as the essay for the pictorial section of this book. Besides, Reinhold Mißelbeck has described the contribution to modern art that Coburn made with his photographs. In her text, Marianne Fulton, who is the chief curator of George Eastman House collections, describes the museum's Coburn collection. Rachel Stuhlman, chief librarian at George Eastman House, has prepared a meticulous Coburn bibliography. A chronology provides a succinct overview of Alvin Langdon Coburn's life and a detailed list of plates, with precise information about all the works presented in the pictorial section, complete this volume.

In conclusion, I wish to thank all those who helped me bring this long cherished dream of a Coburn exhibition to reality.

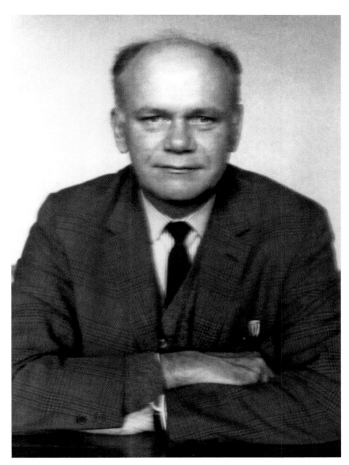

Portrait of Beaumont Newhall by Alvin Langdon Coburn, 1952

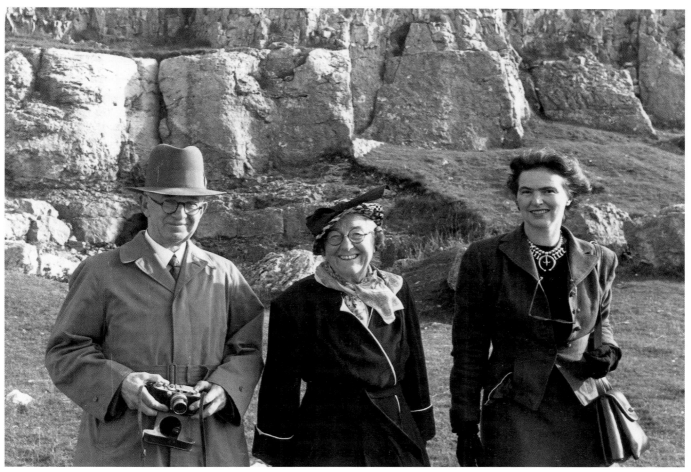

Alvin Langdon Coburn, Edith Coburn and Nancy Newhall, 1952
Photo by Beaumont Newhall

Alvin Langdon Coburn
Portrait by Gertrude Käsebier
c. 1907

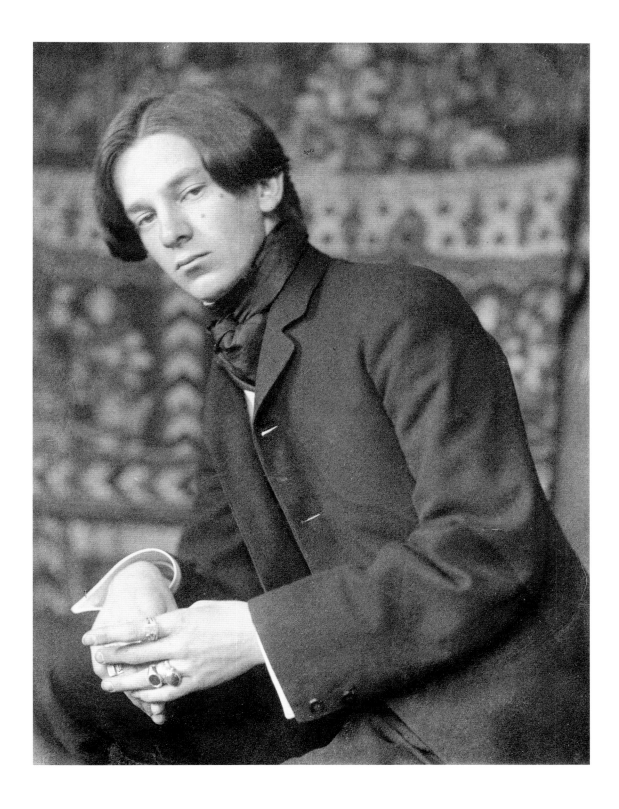

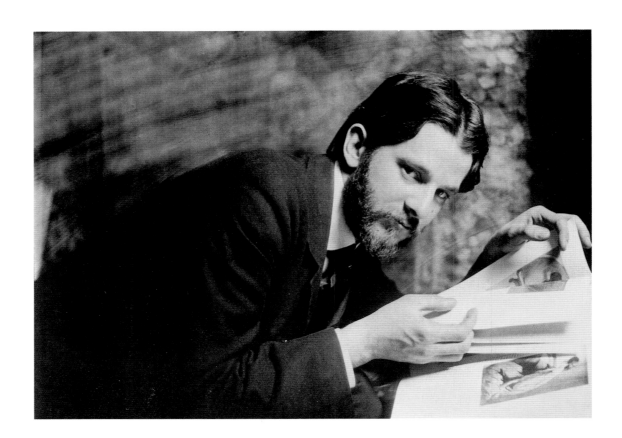

Alvin Langdon Coburn
Photo: Unidentified Photographer
c. 1905

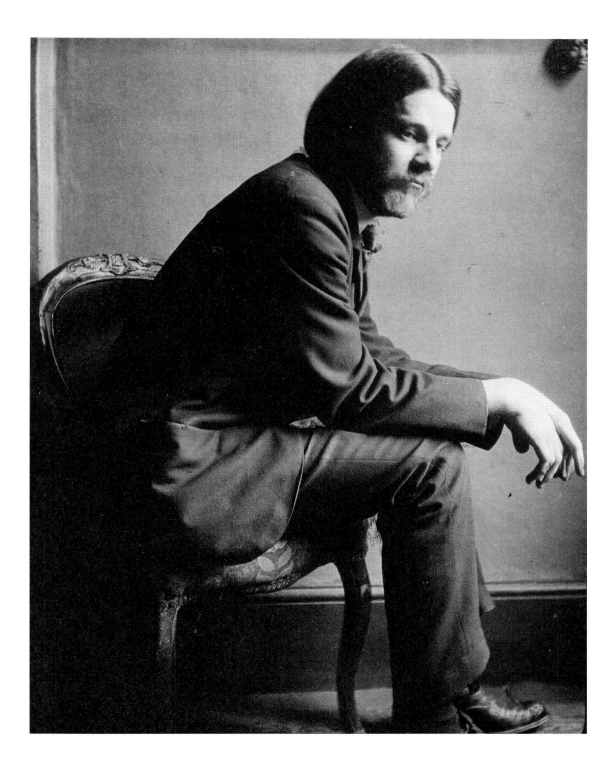

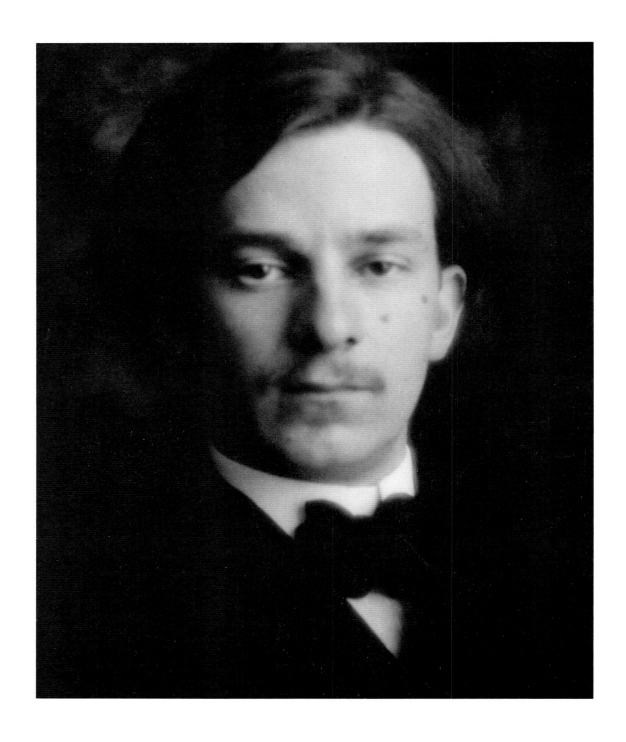

Alvin Langdon Coburn
Portrait by Baron Adolph de Meyer
c. 1910

Alvin Langdon Coburn
"The Copper Plate Press," Self-Portrait
1908

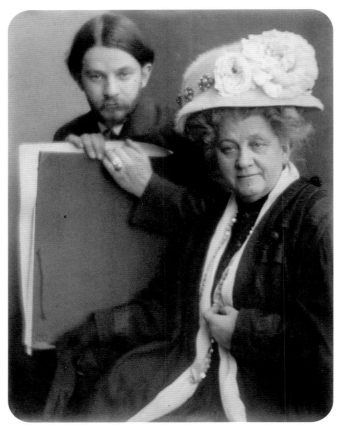

Portrait of Alvin
Langdon Coburn and his mother by
Clarence H. White, 1909

Alvin Langdon Coburn—The Youngest Star
Nancy Newhall

This text was published in 1962 in English in George Eastman House as the foreword to "Alvin Langdon Coburn: A Portfolio of Sixteen Photographs." The essay has lost none of its validity and is still considered to be one of the most important texts on Coburn. Not only was it of considerable significance in raising general awareness of Coburn's works, but it can also be seen as a document of contemporary history, written by a peer and friend of Coburn's, who was also an expert on his work. Nancy Newhall and her husband Beaumont Newhall were together responsible for bringing the Coburn collection to George Eastman House.

ALVIN LANGDON COBURN—the sonorous name comes echoing down to us from the first decades of the Twentieth Century, born by the voices of Alfred Stieglitz, George Bernard Shaw, Henry James, Ezra Pound and many others.

Through Coburn—his remarkable memory, his faithful diary, his voluminous scrapbooks, his collections of paintings, rare inscribed books, and photographs by his friends—we can look back into those first decades. In his own photographs we meet face to face the writers, painters, musicians, sculptors, photographers who in those years were groping for the concepts that still dominate our thinking. We see these men without dramatics, as they were wherever they were when a friend who was often a colleague saw them. We see cities—London, New York, Paris, Pittsburgh, Boston, Edinburgh—each with its individuality revealed by the moods of light and season. We see the shapes of the new century—skyscrapers, bridges, smokestacks—evolving, thrusting, leaping into space. And we see all this through the eyes of a photographer of the company of Stieglitz, Steichen and Clarence H. White. A member of the Photo-Secession, a friend of the Cubists, Vorticists, and Imagists, Coburn worked with the literary titans of the day toward a new medium of words and pictures. Celebrated even then for having an eye that saw pictures where others saw nothing, he looked down from the skyscrapers and made "a Cubist fantasy" of what he saw; a little later he dared separate form from subject and made the first true abstractions in photography. Most of these achievements were crowded into seventeen short years.

"Possibly the youngest star in the firmament," wrote Alfred Stieglitz in 1904, when Coburn was twenty-one: "… an indefatigable, enthusiastic worker and student." In photography, which tends to be an art of the mature mind, Coburn was an infant prodigy.

He was born in Boston on June 11, 1882, with ten generations of Massachusetts behind him. Boston in those days still had its look of London; even now, a Bostonian in London feels he has come home. From the Puritan divines and the Transcendentalists, Boston inherits its deep interest in the study of religions; from the Puritans also, as well as from Emerson, Thoreau, and their friend the sculptor Horatio Greenough—who was the first to hail the beauty of functional forms—Boston inherits its feeling for the austere and plain, the lean, the light, the vital. And from its long seafaring past, comes Boston's love of the Orient, its ascetic mysticism and its splendor. Every old New England family cherishes jades, porcelains, and lacquered chests inlaid with ivory and mother of pearl,

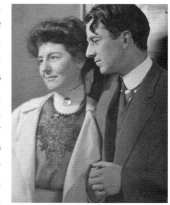

Clarence H. White
Alvin Langdon and Edith
Coburn, 1912

brought back in the clipper ships from China. "From a very early age," wrote Alvin, "I have been interested in things Chinese; I could eat with 'chop sticks' almost as soon as I could with a knife and fork."

When Alvin was seven his father died, and his mother, a remarkable woman whom Stieglitz was to list as "not the least" of Coburn's many advantages, took him to visit her family in California. Here Alvin met the peoples, foods, arts, and even the landscapes of both the Orient and the Mediterranean, for California, when fogs sweep in from the Pacific, becomes a Chinese landscape, while under a hot sun and a deep blue sky its white cities stand sharp as Spain upon its massive hills.

In California, on his eighth birthday, two uncles gave him a 4 x 5 Kodak camera with fifty exposures in it, and showed him how it worked. Back home in Dorchester, Massachusetts, in the old red house among the horse chestnuts, Alvin was soon coating blue print paper in dim, shuttered rooms and setting his printing frames out in the sun. The results, he soon perceived, were "villainous." He plunged to the other extreme, arty techniques such as gum and glycerine. Such attempts to evade Straight Photography he regards as the measles and mumps of the growing photographer, easy to survive when young, but serious and sometimes damaging to the adult—another reason, he believes, why photographers, like musicians and linguists, should begin as children.

The Orient continued to excite his eye and his thinking. From 1890 to 1897 the Orientalist Ernest Fenollosa was bringing to the Boston Museum of Fine Arts treasures from China and Japan. Instead of household objects, Boston now beheld sculpture, architecture, screens and scrolls, ceremonial bronzes, robes worn by priests and emperors. For the first time, undoubtedly, Boston learned that

the highest and purest art of China and Japan is apparently the simplest: exquisite calligraphic strokes of black or grey on pale silks or papers.

By the time he was fifteen, Alvin's photographs were being exhibited in Boston. That same year, 1898, he climbed up Beacon Hill to a house filled with mystery and incense, and together with what seemed all Boston society, crowded up narrow stairs to see an exhibition of the strange, somber "sacred photographs" of Fred Holland Day. For a year Day had let his hair and beard grow while, like a player in a village Passion Play, he prepared himself to pose as the Christus in the Crucifixion. Day was a distant cousin of Alvin's—everybody was related in an earlier Boston—and Alvin ventured to bring him a portfolio of his own efforts. Day's response was to take him as pupil and protégé. To any Bostonian, a year or two of study in Europe appears the proper preparation for a career, so in the summer of 1899, Day shepherded Alvin and his mother to England. Here Day took the boy to the photographic great to study techniques and observe approaches. One of the first was Day's friend Frederick Evans—"red headed, bandy-legged, dynamic," as Alvin describes him—a retired bookseller renowned for his photographs of cathedrals and the perfection of his platinum prints. Evans remarked with pleasure that Coburn had "none of that cheeky indifference as to the taking of pains, to mastery of technique, to hard work" so common among American amateur photographers at the time. Alvin even taught Day, his master, how to develop and print. Previously Day had regarded the image on the groundglass as the climax of creation; the darkroom drudgery could be done by assistants, providing one kept a critical eye on results. Alvin, however, not only composed his image to the edge of the groundglass but visualized his finished print on that groundglass before he made the exposure. By 1900 he could take a mudflat, a few random fenceposts and a distant cart dumping rubble and make a

photograph of a shimmering space linked by dark accents to broken lights and darks. "The Dumping Ground" is an immature image, but the daring perception behind it is already visible.

Three of Alvin's prints were hung in the 1900 London Salon, then the leading international annual, and nine more were considered by Day worthy of the extraordinary exhibition, *The New School of American Photography*, which he was putting on at the Royal Photographic Society. Day's show was not fully representative; Alfred Stieglitz, to whose zeal the New School owed much of its fire and originality, refused to send his work. Nevertheless, the iconoclastic and poetic force of the Americans shocked London; there was outrage and wild applause.

In Paris, Coburn met the tall young American photographer and painter Edward Steichen, three years older than himself but already beginning to be known for the theatrical power of his portraits and the brio of his multiple gum prints. The facile gum process did not tempt Coburn to handwork, as it did Steichen and many others.

Alvin Langdon Coburn: "The Dumping Ground," Boston 1900

He used gum to enrich his platinum prints. Platinum has a silvery delicacy and a long scale of greys, but its whites are watery and its darks pale; Coburn used a coating of gum mixed with vandyke brown pigment to deepen the blacks and make the whites gleam.

In Paris he met French pictorialists such as Robert Demachy, who almost succeeded in making a photograph look like a poor pastel by Degas. Coburn began to feel that the exclamation most Pictorialists hoped to evoke: "Why, it looks like an etching!" (or a pastel) was not a compliment but an impertinence. For himself, he intended to be a photographer, and he desired that his work be judged as photographs.

He and his mother continued on through France into Switzerland and Germany, then back to Boston in 1901, and out to California in 1902. They were brisk Bostonians and this was the era of the globetrotters. They could go where they liked; they had independent means. Blithely they crossed the continents on the thundering trains; blithely they boarded the ocean liners, and heard from their decks the deep whistle blasts find new echoes among the fast rising towers of New York City.

Coburn was full of curiosity and delight, and he was tireless. While in California, he photographed four of the Spanish mission churches. The series of articles he wrote about them for *Photo-Era* marks the beginning of his interest in interpreting places. Then back to Boston again, and down to New York.

Here Alvin was welcomed by the newborn Photo-Secession. Stieglitz, infuriated by wishy-washy Pictorialists who could not recognize genius when they saw it, by big business which cared nothing for quality, and by art museums which refused to recognize photography as art,

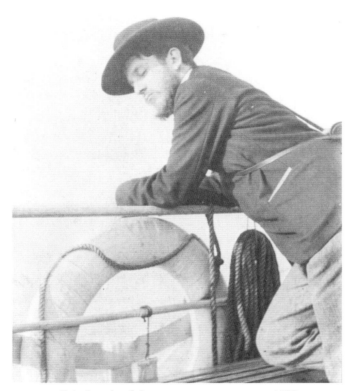

Alvin Langdon Coburn on an ocean voyage, c. 1889

encouragement." And of Clarence H. White: "... one of the finest artists photography has produced. He is never dramatic, but always subtle. He exploits the Platinum process in all the delicacy of its tonal range. He is never cheap or commonplace, but always original, and his influence on American pictorial photography cannot be overestimated." Coburn was drawn also to Gertrude Käsebier, old, valiant, and kind, for whom each portrait was a new adventure.

The Photo-Secession elected Coburn to membership on December 26, 1902. They were bringing out the first number of their magnificent quarterly, *Camera Work*, tipping in with their own hands the sensitive photogravures on Japan tissue which Stieglitz had watched and cosseted throughout their engraving and printing. They did not yet have a gallery. Coburn's first one-man show was held at the Camera Club of New York in January 1903. Stieglitz found in his work "much that was original and unconventional."

For a while Coburn worked in Käsebier's studio; then he went back to Boston and opened his own studio. But studios, to Coburn, who later had one in New York and then another in London, were places to work and display prints rather than businesses. He was still

had suddenly "seceded" and formed a group of the most brilliant and dedicated photographers in America. He called it "The Photo-Secession." Steichen, now back from Paris, Clarence H. White, and Gertrude Käsebier were among the first to join him. Again Coburn studied and observed—and photographed. Of Stieglitz, the catalyst, with his extraordinary force and tenderness, Coburn wrote many years later: "... of course he was the heart and soul of the movement ... did wonderful work for the recognition of Pictorial Photography, but he was a bit of a Dictator and liked to run things his own way! I was young and full of the zest of life, and did not always agree with his policy, but I was very fond of him, and I owe him much kindness and

the student; the summer of 1903 he spent with the painter Arthur Dow, a friend of the Photo-Secession, and used palette or camera as he chose. Here his eye was sharpened rather than weakened, like many of his contemporaries, by a further study of Japanese art. He saw the pale creeks winding through the Ipswich

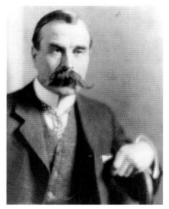

Alvin L. Coburn: George Davison, 1909

marshes as a dragon form; he transformed what one critic described as "the back of a row of city houses over a six-foot board fence" by "taking the most severe lines and the blankest of blank spaces and reducing them to a work of art by the use of delicate tonality." Sidney Allan, the brilliant and erratic critic who chose the pseudonym, Sadakichi Hartmann, commented that Coburn was "beginning to see objects, insignificant in themselves, in a big way." On November 21, 1903, the Linked Ring, an international society then composed of leading photographers only, elected Coburn to membership.

The first number of *Camera Work* to present a portfolio of Coburn's work appeared in April 1904, and it was there that Stieglitz hailed him as "the youngest star." These were great honors, but Coburn humbly went on learning. If one year Frederick Evans felt he lacked a keen observation of light, the next year Evans could write of "London Bridge"—"perhaps the very truest rendering of sunlight photography has yet achieved." And Sadakichi Hartmann, after praising his landscapes: "... he seems to have a natural gift for line-and-space compositions and has solved various problems which even would have set a Stieglitz or a Steichen thinking ..." remarked that: "His portrait work, however, is at present rather unsatisfactory. He seems to lack the gift of the characterization."

Coburn's response to this was to plunge into a project that was to engross him, off and on, for the next eighteen years: "Photography ... brought me into touch with many of the people I was eager to meet: the pioneers and advanced thinkers and artists of that time." With the help of Periton Maxwell, editor of the New York *Metropolitan Magazine*, he made a list of leading literary figures, most of whom were British, and began a course of intensive reading: "... it was my practice before meeting my subjects, to saturate myself in their books so that I might previous-

Portrait of George Bernard Shaw by Alvin Langdon Coburn

ly come to know something of the inner man." In the spring of 1904, Coburn went again to England; suddenly he saw London in its splendor. He scribbled to Stieglitz: "Blessed is the man who found his work—after all there is no place like London. I have never really done any photographic work before—wait until you see the new stuff!"

Late in July, he decided to begin his portrait series with the fiercest and least predictable lion of them all. He wrote a little note to George Bernard Shaw, asking if he might come to Welwyn, where Shaw was living that

summer, and make his portrait. Shaw, an enthusiastic dabbler in photography, already knew Coburn's work; he wrote back yes, and instead of lugging all that stuff, would Coburn like to use any of his own three cameras, or his lenses, or his Cristoid films? He had no darkroom but the bath could be converted. One's admiration for great men seldom extends to a trust in their cameras; Coburn preferred his own 8 x 10. August 1st was a Bank Holiday; there were no carts or carriages to hire. But there at the station was Shaw, with a long staff to sling the camera on; each taking one end, they trotted off coolie fashion. Shaw was the perfect model—"with enough of the actor to know the value of a pose." Coburn, changing films in the bath-darkroom made at least fifty exposures. It was the be-ginning of a lifelong friendship.

The next author Coburn approached was that strange figure, G. K. Chesterton, poet, journalist, critic and mystic. Chesterton was also living deep in the country. But nobody met Coburn at the station and there was not even a wheel-barrow to hire. Coburn toiled on alone under his load; it was a hot, hot day. Suddenly he saw, sitting in the shade of a tree and clad in a green Tyrolean suit, Chesterton himself, busily scribbling away at a column on cabbages. Coburn made the portrait on the spot, and took the column back to London with him.

By the second week in September, Coburn had photographed five more authors, and a painter, Frank Brangwyn. Feeling this project well begun, and that he could do with a little respite, he went up to Scotland and acquired three more projects. Two he caught by contagion from J. Craig Annan of Glasgow, a fellow member of the Linked Ring. As a boy, living in Rock House, at the foot of Calton Hill in Edinburgh, Annan heard his father tell how his friend, the landscape painter David Octavius Hill, photographed against these same walls and doors the

Alvin Langdon Coburn: Gilbert Keith Chesterton, c. 1904

divines, great ladies, poets, explorers and sculptors—even the huntsmen and small kilted boys—of the middle 1840s. Moved by the noble simplicity and dignity of the few prints he saw, Annan made prints from the Calotype negatives in the original spirit. Praise from such artists as Whistler helped him launch the excited rediscovery of this forgot-ten pioneer. Coburn resolved to collect the work of early masters himself. From Annan he acquired the same con-cave mirror Hill and Adamson had used to reflect light into the shadows when sunlight fell too harshly.

He saw Annan making, from Hill's negatives as well as his own, magnificent photogravures. If Annan could etch and ink and print such things himself, then Coburn

could do no less than try. P. H. Emerson, the physician and poetic documentarian who in the 1880s fired the opening guns in the battle for photography as an art in its own right, had been the first to experiment with and recommend photogravure. The three years Stieglitz worked as a professional photoengraver lay behind the beautiful gravures in *Camera Work*. There was no doubt in Coburn's mind that a photogravure, when made by the artist himself or supervised from start to finish by him, could equal an original print in intensity. Further, a photogravure was permanent, and a thousand copies or more could be run off with ease.

The city of Edinburgh was the greatest excitement. With *Stevenson's Edinburgh: Picturesque Notes* as his guide, Coburn lugged his 8 x 10 camera up steep alleys to look back at the Castle, entered ancient and once noble closes, waited in Greyfriars Cemetery until cats came to bask on sunlit, ancient tombs. Love of places, and patience to wait like "a cat at a mousehole" for the moments of their transfiguration, became a part of him forever.

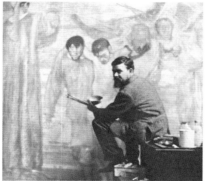

Alvin Langdon Coburn: Frank Brangwyn, 1913

Then he went back to London and the pursuit of portraiture. There were other problems than his own shyness and hesitation to intrude. The novelist George Meredith was said to have a horror of photography. So Coburn, one beautiful October day, "took a little portfolio of my work under my arm. I had no letter of introduction, though I could easily have obtained one. I just walked up the drive to his little ivy-clad house, with a song in my heart to match the day, and my luck was with me. I was at once shown into his presence." This was a mistake; Meredith was expecting another visitor.

"... What a head! I think I have never seen any modern person who was even remotely like him. He resembled an ancient Greek bust, a head of Zeus, calm in its tranquillity, regal in its dignity. And what a model of perfect gentle courtesy; he never let me know that an error had been made in my favor, but looked at my portfolio with obvious interest, even enthusiasm ... he was firm in his determination not to give me a sitting. He said that he did not want to be photographed in his age and made to look like an old monkey, as Tennyson had been." This was not Coburn's opinion of the magnificent portraits Julia Margaret Cameron made of Tennyson, though Tennyson himself wrote under one print, "The dirty monk."

Coburn did not press Meredith; he noted his exclamation, "How beautiful!" over a print of a young mother suckling her child, and next day, sent him the print with a note on what a pleasure it had been to meet him. Meredith wrote back, "You heap live coals on my head." Contritely, he offered to introduce Coburn's "poetically artistic work" to some editor of illustrated journals, or would Coburn prefer to photograph his daughter? Coburn chose the daughter, who insisted first on a family group and then on each member separately. When Coburn saw that luminous head at last in his groundglass, he felt much as the maligned Mrs. Cameron did: "When I have had such men before my lens ... the photograph taken has been almost the embodiment of a prayer." He wrote, "If I have done no other thing in my life, I have made a worthy portrait of George Meredith."

Nevertheless, Coburn was slow in outgrowing his timidity in the presence of the great. A year later, when

Shaw took him to meet and photograph H. G. Wells, whose startling novels projected life in the Twenty-First century: "... I remember how nervous I was, and how I spilled a cup of very hot tea in my lap, and how I had to put on a pair of Wells's trousers while my own were dried! I really was a very shy young man in those days."

In New York the winter of 1905, he was commissioned by *Century Magazine* to do a series of portraits of American authors, including Mark Twain and Henry James, to whom he was instantly drawn: "There are some people you cannot help liking the moment you see them, and Henry James was, for me, such a person." At the 1905 London Salon, a reviewer noted:

> *"A. L. Coburn ... has made a leap this year ... and with Edward Steichen shares the honors of the American section ... Mr. Coburn, it is clear, has not endeavored to pose his sitters to suggest characterization, but has relied upon the management of light to convey his intention. Sparkling illumination surrounds the buoyant head of Mark Twain and one thinks of trifles light as air. A grey film seems interposed between the observer and the grim seer, Chesterton ..."*

On November 24, 1905, The Little Galleries of the Photo-Secession opened at 291 Fifth Avenue, New York. Three small rooms in quiet colors, with lowered ceilings and good light—that was all, yet they were to be the center of storm and triumph, they were to blaze with controversy and beauty. Steichen, being also a painter, proposed, and Stieglitz agreed, that they would from time to time show "art productions, other than photographic." The first year was devoted to photography; the achievement of American, British, German, Austrian and French photographers was seen in one-man, two-man, and small group shows. As

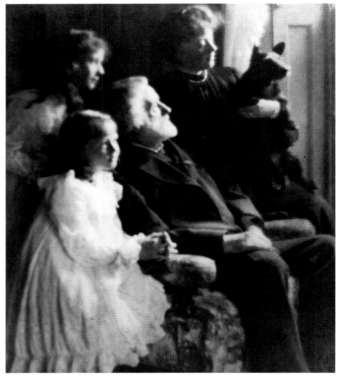

Alvin Langdon Coburn: George Meredith and family, 1904

early as 1906, a member of the Photo-Secession, Joseph Keiley, could state in *Camera Work*: "... the real battle for the recognition of pictorial photography is over. The chief purpose for which the Photo-Secession was established has been accomplished—the serious recognition of photography as an additional medium of pictorial expression."

Early in 1906, the Royal Photographic Society decided to give Coburn a one-man how. Shaw, when Coburn told him the news, said, "You will need someone to beat the big drum for you. I will write you a preface." In those days Shaw took great delight in turning the guns of art critics on themselves; if they disdained photography as easy and

mechanical, he claimed that painting was easier, quicker and more mechanical than photography. Neither could he ever resist dropping a few bombs among the duller photographers. In the preface for Coburn's catalogue he managed very neatly to do both.

"Mr. Alvin Langdon Coburn is one of the most accomplished and sensitive artist-photographers now living. This seems impossible at his age— twenty-three; but as he began at eight, he has fifteen years' technical experience behind him. Hence, no doubt, his remarkable command of the one really difficult technical process in photography—printing. Technically good negatives are more often the result of the survival of the fittest than of special creation: the photographer is like the cod which produces a million eggs in order that one may reach maturity."

He then proceeded, by a series of delicate insults, to infuriate, enchant and convulse his audience by his comments on outstanding photographers noted for their process in printing; as for Coburn:

"If he were examined by the City and Guilds Institute, and based his answers on his own practice, he would probably be removed from the class-room to a lunatic sylum. It is his results that place him hors concourse."

Then Shaw really hit his stride:

"Look at his portrait of Mr. Gilbert Chesterton, for example! 'Call that technique? Why, the head is not even on the plate. The delineation is so blunt that the lens must have been the bottom knocked out of a tumbler; and the exposure was too long for a

vigorous image.' All this is quite true; but just look at Mr. Chesterton himself! He is our young Man Mountain ... who is not only large in body and mind beyond all decency but seems to be growing larger as you look at him—'swellin' wisibly' as Tony Weller puts it. Mr. Coburn has represented him as swelling off the plate in the very act of being photographed, and blurring his own outlines in the process ... You may call the placing of the head on the plate wrong, the focussing wrong, the exposure wrong, if you like, but Chesterton is right; and a right impression of Chesterton is what Mr. Coburn was driving at ... It is the technique that has been adapted to the subject. With the same batch of films, the same lens, the same camera, the same developer, Mr. Coburn can handle you as Bellini handled everybody; as Hals handled everybody; as Gainsborough handled everybody; or as Holbein handled everybody, according to his vision of you. He is free of that clumsy tool—the human hand—which will always go its own single way and no other. And he takes full advantage of his freedom instead of contenting himself, like most photographers, with a formula that becomes almost as tiresome and mechanical as manual work with a brush or crayon. In landscape he shows the same power. He is not seduced by the picturesque, which is pretty cheap in photography and very tempting; he drives at the poetic, and invariably seizes something that plunges you into a mood, whether it is a cloud brooding over a river, or a great lump of a warehouse in a dirty street. There is nothing morbid in his choices: the mood chosen is quite often a holiday one ... the mood that comes in the day's work of a man who is really a free worker and not a commercial slave. This is done without any impoverishment or artification; you are never worried

with that infuriating academicism which already barnacles photography so thickly ... Mr. Coburn goes straight over all that to his mark, and does not make difficulties until he meets them, being, like most joyous souls, in no hurry to bid the devil good morning."

The boom of the big drum was heard on both sides of the Atlantic. Sheafs of Coburn's photographs were appearing in the magazines: *The Metropolitan Magazine*, New York, February 1906: eight photographs; "Photographic Impressions of New York." *The Pall Mall Magazine*, London, April: seven photographs; "A New Aspect of London." *The Metropolitan*, May: five photographs, with an article on Coburn by Shaw. *The Pall Mall*, June: six photographs interpreting the setting for Charles Dickens's unfinished mystery story, *Edwin Drood*, with a preface by one of Dickens's daughters. And *Camera Work*, July: five photographs, with the Shaw preface, and a portrait by Shaw of Coburn.

Meanwhile Coburn, like any apprentice, was studying two nights a week at the London County Council School of Photoengraving: he was "proud to be a craftsman as well as an artist." He went on with his portraits. At Meudon, in April, he made a heroic and vigorous head of Rodin, to whom Steichen had become almost another son. In Paris, he watched Steichen develop, in his own dark room, a color transparency with little more difficulty than an ordinary negative. There were many such color processes, but Coburn joined Steichen in believing that Autochrome, this new three-color process developed by the Brothers Lumière, was the finest so far. It produced only a transparency, unstable like all transparencies dependent on dyes, but the image gleamed like a jewel from its dark mirrored case. They all fell in love with it, amateurs, artists, publishers. Stieglitz introduced it to New York on

September 30, 1906, with a show at "291" of Autochromes by Steichen, Frank Eugene, and himself. Coburn wrote Shaw, what about a portrait in Autochrome? Shaw, whose red beard was fast going grey, wired back, "Hurry, while there is still some color." When they got together, they decided a plaid might help; this portrait heads an early biography of Shaw.

But Coburn's search for the lights and moods that reveal both places and peoples was leading him in another direction just then: photographs to interpret words. The ghost of Stevenson had been his first guide, and Dickens his second; now he began to work with living masters.

The most fascinating of many collaborations began in June 1906, with a letter from Henry James, now back in England and living at Lamb House, Rye. He was preparing a collected edition of his novels and tales, and needed a new portrait as frontispiece. Would Coburn come down to Rye and photograph him? Coburn "produced a result that evidently satisfied him, for he subsequently suggested that I should make photographs to be used in other volumes of the forthcoming collected edition: and thus began our friendship." Coming from James this was an extraordinary proposal, for, as he wrote in his preface to *The Golden Bowl*, he regarded illustration in general as "a lawless incident," and feared

"the picture-book quality that contemporary English and American prose appears more and more destined, by the condition of publication to consent, however, grudgingly, to see imputed to it ... Anything that relieves responsible prose of being while placed before us, good enough, interesting enough, and if the question be of picture, pictorial enough, above all in itself does it the worst of services, and

may well inspire in the lover of literature certain lively questions as to the future of that institution."

Nevertheless, James found it

"charming ... for the projector and creator of scenes and figures ... to see such power as he may possess approved and registered by the springing of fruit from his seed ... One welcomes illustration in other words, with pride and joy; but also with the emphatic view that, might one's 'literary jealousy' be duly deferred to, it would quite stand off and on its own feet, and thus, as a separate and independent subject of publication, carrying its text in its spirit, just as that text correspondingly carries the plastic possibility, become a still more glorious tribute."

What he proposed to Coburn was that together they should hunt through the camera for "images always confessing themselves mere optical symbols or echoes ... small pictures of our 'set' stage with the actors left out ..." There were to be twenty-four of these and each would serve as a frontispiece to one of the twenty-four volumes of *Novels and Tales.*

They knew, of course, that every connotation of light, mood and detail must be right, and this hunt through reality for images which by now existed in his own mind, "from the moment I held it up to my fellow-artist in the light of our fond idea"—fascinated James. "The looking so often flooded with light the question of what a subject, what character ... is and isn't."

The first image found was of James's own home, Lamb House, which appeared in *The Awkward Age* as "Mr. Langdon's." In October, Coburn went to Paris, "armed with a detailed document from James explaining exactly what he wanted me to photograph." One symbol was to be a porte-cochère in the Faubourg St-Germain: "His knowledge of the streets of Paris in this particular quarter was amazing. He enumerated nine or ten streets I was to traverse ... His letter continued: 'Once you get the type into your head, you will easily recognize specimens by walking in the old residential and noble parts of the city ... Tell a cabman that you want to drive through every street of it, and, having got the notion, go back and walk and stare at your ease.' This was thoroughness! This was H. J.'s way of himself approaching a problem." Another of the six subjects to be found in Paris was "the pedestal of some pleasant old garden-statue. Go to the Luxembourg Gardens to look for my right garden-statue (composed with other interesting objects) against which my chair was tilted back." James finished these instructions "with the kindly benediction: 'My blessing on your inspiration and your weather.'" When they were able to "gloat together over the results," James was "even as a boy, always displaying an unquenchable and contagious enthusiasm over every detail concerning these illustrations. That was what made it such a joy to work with him."

Coburn's next expedition was to Italy: two images to be found in Rome, two in Venice. He found himself in Venice at Christmas—"never before or since have I felt so cold and damp"—and his instructions included how to approach a certain place "either on foot through narrow winding footways, or by gondola, with the advantages of each method."

The next images were to be of London; Coburn and James went hunting together, these two cosmopolitan gentlemen, one old and one young, and found it definitely an adventure. There was the lovely afternoon they found the perfect house at the perfect moment, and hun-

gry and exhilarated, sought a teashop but found only a bakery, and went down the street munching large buns like schoolboys. There was the day they took a hansom cab out to Hampstead Heath in search of a certain group of trees, and James left his gold-headed cane with the driver as assurance of their return. James concluded that "London ends by giving one absolutely everything one asks ... we had, not to 'create,' but simply to recognize—recognize, that is, with the last fineness." Thus they could wait in Portland Place, confident that "at a given moment the great featureless Philistine vista would itself perform a miracle, for a splendid atmospheric hour, as only London knows how; and that our business would be then to understand."

James regretted that the small format chosen for the *Novels and Tales* did not permit full-size gravures: "This series of frontispiece contribute less to ornament, I recognize, than if Mr. Alvin Langdon Coburn's beautiful photographs, which they reproduce, had had to suffer less reduction; but of these which have suffered the least, the beauty, to my sense, remains great ..." The last three images were to be found in New England and New York. Stieglitz asked Coburn for a one-man show in the spring; Coburn wrote him from London on January 12, 1907: "I am working hard on a lot of new things in black and white and colour which I always make with the idea in the back of

Alvin L. Coburn: Venice

my head, what will A. S. think of it? It keeps me up to the mark I can tell you!" A week or so later with Baron Adolph de Meyer, another young photographer about to be presented at "291," Coburn finished an "Exhibition of Modern Photography" at the Goupil Gallery, then crossed to New York, found James's images, helped hang the show at the Little Galleries—Stieglitz commented that it drew "crowds second to none"—went to Washington to photograph Theodore Roosevelt in the White House on April 1st, and a few days later was hanging another one-man show at the St. Botolph Club in Boston.

This pace became characteristic; for the next few years, Coburn shuttled between the continents, now in London, helping the Salon put up its increasingly dull annuals, now in New York where "291" was beginning to show, more and more often, the work of painters and sculptors, unknown beyond the Left Bank, who bore such names as Matisse, Cézanne, Picasso, Braque, Brancusi. Of the new group at "291," Coburn was most attracted to "that great modern American painter, Max Weber, who had the vision—even in those early days—to see the possibilities of photography as a field of artistic endeavor." Weber was exhorting photographers to photograph design and emotion; subject was immaterial—golf clubs, a table, the side of a barn—anything could serve as a springboard. Coburn had been doing exactly that for years.

Coburn's work was now in constant demand by publishers and editors; four photographs of flowers and old gardens for the American edition of Maurice Maeterlinck's *The Intelligence of Flowers*; nine photographs to go with John Masefield's "Liverpool, City of Ships" in *The Pall Mall*, for March, 1905. Portraits for biographies; Autochromes of Charles Freer's fine collection of Oriental art in Detroit; photographing the sandhogs who were digging the tunnels under the rivers of Manhattan, going down with

them into those rough, dark and leaky burrowings. To Dublin, to make portraits of the leaders of the Irish Renaissance: "... I captured Yeats by flashlight, reciting one of his poems. He wore a velvet coat and a flowing black tie at a dinner given in his honour by Lady Gregory." Yeats was also getting out a *Collected Works* in 1908, and refused to have any other photographer than Coburn, "who," he wrote, "is celebrated in our world." But Coburn's portraits were uncomfortably perceptive; in the end Yeats chose pastels and drawings which showed him as he wished he were. To Connecticut, to spend a weekend just before Christmas, 1908, with Mark Twain at "Stormfield"; to the White House again, for a portrait of the new President, Taft.

Month by month, sometimes week by week, the magazines crowd the record: in the United States, *Harper's, Everybody's, The Metropolitan, Cosmopolitan, The Century, Literary Digest;* in Britain, *The Sketch, The Pall Mall, Illustrated London News, International Studio.* Demands for pictures came from France and Germany also; of course there were always the photographic magazines and, whenever Stieglitz wished, *Camera Work.*

Anytime he could, whatever hemisphere he happened to be in, he departed for a week or more of wonder and delight with his camera. A spring wandering through Italy, from Venice through the hilltowns down to the ruined temples of Sicily; another spring sailing down the coast of Spain in a steamer with a load of sardines; a summer in the medieval and baroque villages of Bavaria and the mirrored old towns of Holland; an autumn in Scotland or Ireland. He never felt he knew a place until he had photographed it. He waited for "the visions of life that flash and are gone like the sun glancing from the white side of a ship at sea." Clouds and water could hold him for hours—"the subtle play of sunlight on moving water ... the poetry of liquid surfaces."

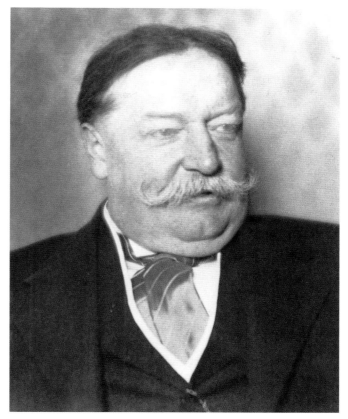

Portrait of President Taft by Alvin Langdon Coburn, 1910

For two nights a week during the last three years, whenever he was in London, he had been studying photogravure. In 1909 he bought a charming old house in Hammersmith so close to the Thames that he called it "Thameside" and now and then had problems when the river rose in flood. In "Thameside" he set up not only a darkroom but two presses, and began work on two books and a set of large gravures. He etched and steel-faced his plates, ground his own inks, and pulled proofs on various papers until he had a model his printer could follow to the end of the run. The printer, having been trained on

Alvin L. Coburn: Coburn's house, Thameside

postage stamps, made his first proofs in "a beautiful bright blue." Nevertheless, between them, they produced fifty thousand impressions in two years. The first book of these gravures was *London*, 1909, twenty plates with a preface by Hilaire Belloc, on the peculiar growth and significance of the city, which has no relation beyond title with Coburn's photographs. But the second book was *New York*, 1910, and H. G. Wells understood both the function of photographs and the writer's function; in a page and a half, briefly and brilliantly, he gave the photographs wide dimensions of thought and action; he summarized the dynamics of rock, rivers, sea, people that were crystallizing into Manhattan, even to "the exhilaration of the air." He foresaw:

"Our time will go to our descendants heavily and even over-abundantly documented, yet still I fancy these records of atmosphere and effect will gleam, extremely welcome jewels, amidst the dustheaps of carelessly accumulated fact ... Mr. Coburn has already done his share in recording that soft profundity, that gentle grey kindliness which makes my mother London so lovable ... And now here he has set himself ... to give in a compact volume the hard, clear vigour of New York, that valiant city which even more than Venice rides out upon the sea ... its lights increase and multiply until they blind the stars. A hundred years hence people will have these photographs, but I wish Mr. Coburn could show me pictures of New York a hundred years from now."

Wells's next book, *The Door in the Wall and Other Stories*, 1911, contained ten gravures by Coburn.

The theater was another of Coburn's passionate delights; he began photographing, mostly for *The Sketch*, scenes and individual characters from Galsworthy's *Justice*, Meredith's *The Sentimentalists*, and, with special pleasure in the imaginative costumes, Maeterlinck's mystic allegory, *The Bluebird*. During a rehearsal of *Androcles and the Lion* in 1913, he caught Shaw himself in a magnificent lunge, brandishing a sword, telling the producer what he wanted.

He and Shaw planned a book together on *How to Solve the Irish Problem*, and Coburn went to Ireland in the fall of 1910 to serve as Shaw's eyes. After that Coburn sailed for America, but arrived in Buffalo just too late for the opening, on November 4th, of the great Photo-Secession show. Coburn had had a hand in arranging for this exhibition, but it was Stieglitz who made it and Max Weber who directed the installation, bringing the height of the huge classic galleries down by ceilings of blue gauze so that the photographs could gleam and glow in intimacy. The show was an immense success; the Gallery bought thirteen photographs, among them Coburn's "El Toro," for its Permanent Collection. But for many members there was a feeling of farewell. The Photo-Secession had done its work; it was dying and would soon be dead. Stieglitz had come to feel that the creative excitement was gone from photography; that photographers were becoming smug and arty, imitative not only of other arts but of each other. From then on the walls of "291" and the pages of *Camera Work* rarely showed photographs; one show of Adolph de Meyer, and one of Stieglitz himself—during the *Armory show*. Then no more until 1916, when Stieglitz found in the young Paul Strand the dynamic new vision he was seeking.

From Buffalo Coburn went to Pittsburgh, and photographed the steel mills, river steamers, railroad yards in the steam, smoke and snow of December. The drama of industry—the pouring of white-hot steel, the sparks

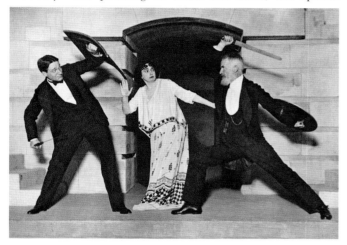

Alvin Langdon Coburn: George Bernard Shaw during rehearsal for "Androcles and the Lion," 1913

around a welder—excited him. Then to Boston, where, in January 1911, he photographed Beacon Hill in the bare low lights and treeshadows of winter; to New York, where he made a portrait of Max Weber. Then he boarded a train for California.

For the first time Coburn understood what it is to be tired; the pace, the production had been incessant. He went up to Yosemite Valley. There was still snow on the peaks and domes thousands of above its exquisite river meadows and forests. For months he immersed himself in this beauty; camped out, climbed, hiked, dreamed, watched the clouds, exulted in storms, lights, horizons. For him, this tremendous reality became most meaningful under cloudlight. Half Dome became a huge, hooded, shimmering shape, accented by the snowdrift still lingering on its peak

and the dark stain of melting down its face. The wind flowing, snow-bent pine on Sentinel Dome he saw as "a Chinese tree," a beautiful arrangement of tones against a pale sky.

In September he went down to the Grand Canyon. To photograph from its terrifying rims and capes was not enough; he hired a guide, and went down the steep trails cut into its precipices. Whenever storm-shadow, sunlight, or rain isolated one of the vast "temples" or gave recession to the abyssal sea of rocks, he photographed; his organization is subtle and daring. At the bottom, a mile almost straight down, he and his guide, with cameras, lenses, film, food, water, and other equipment necessary for survival, crossed the dangerous Colorado in "a wire cage slung on a cable which you operated by a hand-turned wheel to pull yourself over. On the far side, it was necessary to catch semi-wild donkeys with which to continue your journey ..." He camped in unknown and nameless canyons, deep in the "isolated and awful grandeur, with only the rattlesnakes, the wild donkeys, and 'Old John' for company, under the glory of the stars."

In January, 1912, he came back; in snow, what would the Canyon look like? In his excitement he ventured a few feet too far: "... from an cliff in the winter's snow, my foot suddenly penetrated the ice-crusts, and through the hole I saw the abyss of the gorge five thousand feet below! I had gone out on a shelf of nothing more stable than ice ..."

Back in Los Angeles, looking through his negatives, he kept thinking of Shelley's ode, *The Cloud*. He had the poem handsomely set in type, and bound together with six original platinum prints in an edition limited to sixty copies. The photographers around Los Angeles wanted to see his work; he put on two shows for them. Of nearby Long Beach he made an infinite picture—people small and dark

on the sands, bright lights on the Pacific, fog on the horizon—and photographed a roller coaster for sheer delight in the pattern made by its struts and chutes. Then he headed East again; to Boston, where W. Howe Downes of the *Boston Transcript* acclaimed "the surpassing beauty" of *The Cloud*, and commented that the Grand Canyon "has been the despair of art ... Coburn with his camera has been the first to give us any idea of the grandeur and mystery and sublimity ..."

Then he went to New York to organize "An Exhibition Illustrating the Progress of the Art of Photography" for the Montross Galleries. New York, in 1912, he saw with new eyes. After Yosemite and the Grand Canyon he could not wait to look out from its tallest towers. He had plodded up trails to much greater heights; here he could float up in an elevator, cameras and all. He photographed the nearby towers, their endless rows of windows, their plunging verticals. Looking straight down he saw paths shovelled through the snow on Madison Square forming an octopus. In the section *New York from its Pinnacles* of the catalogue of his one-man show at the Goupil Gallery next year, he wrote:

"How romantic, how exhilarating it is in the altitudes, few of the denizens of the city realize; they crawl about in the abyss intent upon their own small concerns ... Only the birds and a foreign tourist or two penetrate to the top of the Singer Tower from which some of these vistas were exposed. No one can deny the verity of the camera, yet surely 'The Thousand Windows' is almost as fantastic in its perspective as a Cubist fantasy; but why should not the camera artist break away from the worn-out conventions, that even in its comparatively short existence have begun to cramp and restrict his medium, and claim the freedom of expression which any art must have to be alive?"

The day after the *Progress of Art* show opened, he married the enchanting Miss Edith Clement of Boston. With his bride he sailed for England; it was his twenty-third crossing since 1900. He has not returned to America since.

Focus, to Coburn as to Stieglitz, White and Evans, was simply an additional control of the image. Coburn, for instance, with a slight degree of out-of-focus, could make the traffic on "London Bridge" (1905) into a dancing river of specular lights; with a degree more, in "El Toro," at the one bullfight he ever attended, he could make the bull a menacing silhouette and the matador a gleam. Mostly, however, the masters preferred a soft clearness, left the blobs of extreme out-of-focus to would-be artists among the amateurs, and the other extreme of needle-sharpness to commercial photographers. Now, however, Coburn found himself desiring more clarity. In *The Pall Mall*, in June, 1913 he wrote:

"I wish to state here very emphatically that I do not believe in any sort of handwork or manipulations of a photographic print or negative. I would much rather have a hard, sharp, shiny old-fashioned silver print ... than the modern trash, half photography, half very indifferent draughtsmanship ... I cannot refrain from quoting Shaw again: 'A man may imitate the noises of a barnyard, and do it very well, but it is an unpardonable condescension all the same.'"

By the spring of 1913, edge and texture had become, for Coburn, as important as tone, and the patterns made by repeated forms an increasing delight. In Paris he photographed the buttresses of a bridge across the Seine, and chimney pots making a structure of accents upon the rooftops. He met Gertrude Stein and "was privileged to go to one of her 'At Homes,' and see her wonderful collection of

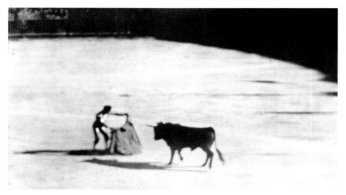

Alvin Langdon Coburn: El Toro, 1906

modern paintings ... it was through her that I met Matisse." With the portrait of Matisse leaning on a stepladder with his glowing palette in his hand, Coburn concluded supervising the thirty-three photogravures for his book *Men of Mark*, which appeared in the fall of 1913. He wrote in his introduction:

> *"I have not attempted to do anything eccentric in the way of portrayals, but I have studied my men and their works with enthusiasm, and in each instance I have tried to catch and reveal the elusive something that differentiates a man of talent from his fellows, and makes life worth while, worth struggling with towards ever greater understanding."*

Immediately he plunged into a new series of portraits; he had in mind not only *More Men of Mark*, but also a series of prominent women, and still another of musicians. That October he went down to Dorchester to photograph the novelist Thomas Hardy; they spent a wonderful afternoon scuffling through autumn leaves to the old Roman amphitheater. Then the writer and editor Holbrook Jackson: "Between us, we nearly blew the roof off a laboratory in Sheffield with a half-pound tin of flashlight powder which was supposed to be damp, but, somehow, wasn't!" The next was that brilliant and truculent figure Ezra Pound, who had recently defined the Imagist movement in poetry and was soon to champion Vorticism, the English variant of Cubism. "And then there was Ezra Pound!" wrote Coburn, in *More Men of Mark*, 1922. "But why do I speak of him in the past tense? Is not our Ezra always with us? At almost any private view of the very latest thing in Super-Modern Art are not his Leonine Mane and Large Lapis Coat Buttons to be found at the very heart and center of the Vortex? ... our Ezra is a fine fellow—a terrible adversary, but a staunch friend."

The series continued, under all sorts of difficulties: "I always make it a point to work under any conditions in which I find my sitter." Anatole France on a stair landing: "we were a bit cramped for space"; Georg Brandes, the controversial Danish critic, in an "olive-green fog"; the painter Augustus John in his Chelsea studio; the sculptor Jacob Epstein on a bitter cold balcony; H. H. Asquith at Downing Street a few months before World War I.

Coburn, of course, was still photographing place and atmosphere, and one of his most exquisite interpretations appeared in a little book *Moor Park, Rickmansworth*, in 1914; twenty plates of the beautiful and ancient country house, its doorways and mantels, its gardens and deer park. In 1914, too, Coburn had privately printed for his friends another *London*, this time with an essay by G. K. Chesterton, and ten of his new photographs. Seven photographs of ships appeared with John Masefield's poem *Ships* in *Harper's Monthly* that Christmas. Music was another of Coburn's passions, and particularly the music of the early Twentieth Century. This was then recorded so rarely that he bought a mechanical piano and had a machine made by which he could cut rolls of music not commercially available, such as Debussy, Ravel and Scriabin. He and J. Dudley

Portrait of Ezra Pound by Alvin Langdon Coburn, 1913

In 1915 he shocked Pictorialists on both sides of the Atlantic by putting on, at the Albright Art Gallery in Buffalo, New York, and at the Royal Photographic Society in London, *The Old Masters of Photography*. This was chosen from his own collection of the work of Hill and Adamson, Julia Margaret Cameron, Dr. Thomas Keith and Lewis Carroll. Some were original prints, some his own prints from the original negatives. It was a summary and a challenge; Pictorialists wondered what, if any, advances in the creation of photographic images had been made during the last half-century.

Alvin Langdon Coburn: Jacob Epstein, 1914

Through Ezra Pound, Coburn found himself getting deeper and deeper into "the Vortex." All the arts were in flight from reality —music, painting, poetry, dance, theater. Pound, as literary executor of Ernest Fenollosa's Oriental papers, had become fascinated by the notes on the classic No dramas of Japan, with their stylized and symbolic use of mask, gesture, music, dance. William Butler Yeats, with his love of the symbol and distrust of the naturalistic, began to write plays in the No tradition. His *At the Hawk's Well*, with Michio Ito as the Hawk, and all players in masks and costumes by Edmund Dulac, was first given in Lady Cunard's living room in April 1916, then revived a few days later by Lady Islington for a war charity. Of course, it was Coburn who photographed the dancers and actors. Early in 1916 Coburn photographed the Vorticist painters Wyndham Lewis and Edward Wadsworth. He wrote of them in 1922:

Johnston "even had made for us two rolls, one each of the first composition of Stravinsky ever to be cut for the Pianola!" Coburn also "was very interested in the patterns made by the holes punched in the paper, and experimented with the sounds made by patterns merely conceived visually! I found that the patterns of Bach were especially beautiful." Among the musicians he photographed were Sibelius, Delius, Moiseiwitch, and Stravinsky.

"Now, you know, I am very fond of these revolutionaries. They care not for the musty conventions of classical art, or the vested interest of the art dealer. 'Theirs not to reason why,' theirs but to square and cube and vorticize, as the spirit moves them ... I wonder what will happen when they get to be established classics! Even now, in a few short years, this possibility is not without the pale of reason. For is not Picasso realizing large rewards for paintings which only yesterday, it seems, were laughed to scorn?"

He was equally prophetic about photography; *in Photograms of the Year, 1916,* he issued a challenge:

"... Why should not the camera also throw off the shackles of conventional representation ...? Why should not its subtle rapidity be utilized to study movement? Why not repeated successive exposures of an object in motion on the same plate? Why should not perspective be studied from angels hitherto neglected or unobserved? Why, I ask you earnestly, need we go on making commonplace little exposures that may be sorted into groups of landscapes, portraits and figure studies? Think of the joy of doing some-thing which it would be impossible to classify, or to tell which was top and which was the bottom! ... I do not think we have begun even to realize the possibilities of the camera."

Elsewhere in the same *Photograms* it was remarked with some irritation that "Alvin Langdon Coburn never settles down," and just then he was preparing to be more unsettling still. "There was a notion at that time that the camera could not be abstract, and I was out to disprove this." He clamped three mirrors together in a triangle, poked his lens into it, and photographed the multiple reflections of

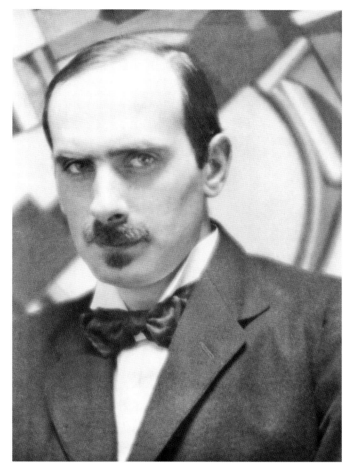

Portrait of Edward Wadsworth by Alvin L. Coburn, London 1916

bits of glass and wood laid on a table with a glass top. "The principle was similar to the old kaleidoscope ... The patterns amazed and fascinated me." Pound came to see; Coburn caught his profile reflected in the mirrors, and made an amusing repeated silhouette reminiscent of a Rorschach test. He called it "The Center of the Vortex." Pound christened the device the "Vortescope" and the results "Vortographs."

When the London Camera Club asked Coburn for a one-man show, he answered yes, if he could show whatever he wished. He chose eighteen Vortographs—and thirteen of his own paintings. To the catalogue, Pound contributed a preface—anonymous at the time, but later reprinted, somewhat shorn, in *Pavannes and Divisions*, 1918. No matter how infuriating one might find Shaw, the lunge and riposte of his wit were a delight. Pound's preface, on the other hand, resembles a series of carefully dropped bricks. One recipient of a brick was Coburn's painting, which Pound dismissed

> "*as roughly speaking, post-impressionist ... there is no connection between Mr. Coburn, as painter, and the group known as the Vorticist group. I am concerned here solely with Vortography. The tool called the Vortescope was invented late in 1916. Mr. Coburn had been long desiring to bring Cubism or Vorticism into photography ... In Vortography he accepts the fundamental principles of Vorticism ...*"

These principles, he explained, were based on Pater's "All arts approach the condition of music," and Whistler's "We are interested in a painting because it is an arrangement of lines and colors." Through Vortography, he proclaimed:

> "*The camera is freed from reality. A natural object or objects may perhaps be retained realistically by the Vortographer if he chooses, and if they form an integral and formal part of the whole. The Vortescope is useless to a man who cannot recognize a beautiful arrangement of forms on a surface ... His selection may be almost as creative as a painter's composition. His photographic technique must be assumed ... These things, however, can be discussed with any intelligent photographer, assuming that*

> *such persons exist ... Vorticism has reawakened our sense of form, a sense long dead in occidental artists. The modern will enjoy Vortograph No. 3, not because it reminds him of a shell bursting on a hillside, but because the arrangement of forms pleases him, as a phrase of Chopin might please him. He will enjoy Vortograph No. 8, not because it reminds him of a falling Zeppelin, but because he likes the shape of arrangement of its blocks of dark and light ...*"

The Vortescope, however, appealed to Pound chiefly as a means of experiment.

> "*Certain definite problems in the aesthetics of form may possibly be worked out with the Vortescope. When these problems are solved Vorticism will have entered that phase of morbidity into which representative painting descended ... That date of decline is still afar off ... Vortography stands below the other Vorticist arts in that it is an art of the eye, not of the eye and hand together. It stands infinitely above photography in that the Vortographer combines his forms at will. He selects just what actuality he wishes, he excludes the rest. He chooses what forms, lights, masses he desires, he arranges them at will on his screen ... The dull bit of window-frame produces a fine Picasso, or if not a Picasso, a Coburn. It is an excellent arrangement of shapes, and more interesting than most of the works of Picabia or of the bad imitators of Lewis. Art photography has been stuck for twenty years. During that time practically no new effects have been achieved. Art photography is stale and suburban. It has never had any part in aesthetics. Vortography may have, however, very much the same place in the coming aesthetic that the anatomical studies of*

the Renaissance had in the aesthetics of the academic school. It is at least a subject which a serious man may consider ..."

Coburn might accept, a little ruefully, Pound's rejection of his paintings, but not the slur on photography. He added a postscript:

"... I affirm that any sort of photograph is superior to any sort of painting aiming at the same result. If these Vortographs did not possess distinctive qualities unapproached by any other art method, I would not have considered it worth my while to make them. Design they have in common with other mediums, but where else but in photography will you find such luminosity and such a sense of subtle gradations? I took up painting as one takes up any other primitive pursuit, because in these days of progress it is amusing to revert to the cumbersome methods of bygone days ... so perhaps my anonymous friend is right in not dwelling unduly on the paintings ... They are not, however, the most important part of the present show. People have been painting now for several years, it is no longer a novelty, but this will go down to posterity as the first exhibition of Vortography."

At the opening, according to one reviewer, Shaw proceeded "to praise the Vortographs with faint damns," Pound gave "a psychological or even physiological defense of Vorticism and Cubism and some sorts of Cubism," and Coburn compared making Vortographs with reading the stories of H. G. Wells. He embarked on the delights of abstraction; one avoided muddy tramps under an 8 x 10 by staying home in front of the fire and manipulating a Vortescope. He claimed that Vortography would do for photography what Cézanne and Matisse had done for painting, and Stravinsky and Scriabin for music, pointing out to photographers that "all the country of the unknown stretched out before them."

A fracas broke out in the photographic press. One man, after looking at a Vortograph every which way, from the back and with a looking glass, confessed: "This Vortograph is uncanny. It haunts me. I begin to see things in it. There is more in it than meets the eye." Another diagnosed Coburn's condition as "Poseuritis ... The complaint is caused by living in a vitiated atmosphere of adulation ... self-expression ... emotional golfclubs 'impossible to classify' or to 'tell the bottom from the top.'" But Frederick Evans, grand old man and friend of Coburn's these many years, led the attack in favor of "sane art" by benignly believing the whole issue no more than the aberration of a generation hardly out of the nursery. "Not even the youngest of us," he quoted, "is infallible." When the Vortographs were shown in Glasgow, an eyewitness reported: "No one member could explain what Mr. Coburn was aiming at. What greater success could any modernist desire?"

British photographers, it appears, were bent one and all, gentlemen and craftsmen to the last, on atrophy. There was plenty of fight going on in America; in 1917 Stieglitz and Steichen threw every photograph faked in technique or attitude out of the Wanamaker Salon and gave the honors to youngsters like Paul Strand, Charles Sheeler and Edward Weston. Then Steichen, who was now in the Air Corps, went to France and began photographing the enemy over the sides of airplanes; Stieglitz, abandoned by his friends because he could not accept the anti-German hysteria, closed "291" and brought *Camera Work* to an end. But Coburn had not been in close touch with "291" for some years; he and his wife both wore the uniform of the Red Cross and they were already rooted in Britain.

They fell in love with Wales, and went to live there. A neighbor across the bay was David Lloyd George, then Prime Minister. Coburn met him at a concert, photographed him in his home, and observed him at the tea table: "... the war was just at its sharpest, all the earth was shaking with the thunder of it, and yet he could sit and chat about the weather and feed the little dog with crumbs ... I saw a very different man at Downing Street, where I went at his suggestion to photograph Foch and Clemenceau."

When the horror of the First World War finally ceased, most people, after the first wild burst of joy, felt stunned. To pick up what was left of their lives, to find themselves again, was slow and difficult, even in America. In Europe, the holes, the losses, the damages seemed almost irreparable. Many—and among them some of the most imaginative and creative younger artists—took refuge in a reckless, hysterical, iconoclastic cynicism; others sought solace in mysticism, or in some personal mixture of the two extremes. Coburn had escaped the worst horrors, but no sensitive person can avoid being involved with mankind. For him, the answer was, of course, mysticism, toward which, through his love of the Orient and his wide acquaintance among mystical poets, writers, and scholars, he had been drawn for years. He began to study and compare religions, and to explore such facets as the Kaballah, Freemasonry, astrology, alchemy. In the Druids, the early Christian mystics, and the Platonic ideals of the Good, the True and the Beautiful he began to find his way. Photography now seemed to him not an end but a means of capturing those moments when Beauty is reflected by the phenomena of this world. He never ceased entirely to photograph—

"... for this is impossible. Once the virus has entered the system it is there until time for us is no more. Whenever I went abroad, and this happened fairly

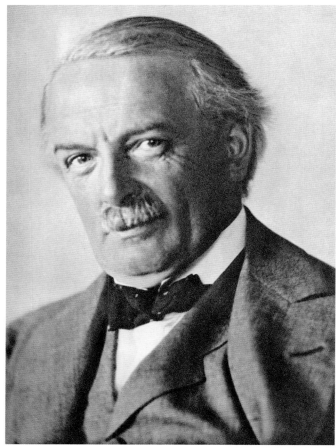

Portrait of David Lloyd George by Alvin Langdon Coburn, 1918

frequently, I usually took a camera with me, and then photography flared up, blazed forth and filled me with the old wild enthusiasm of other and earlier days. Even in Wales, I climbed mountains as an excuse to use a camera on clouds, rocks and little lakes nestling in valleys overshadowed by the heights."

Living in the steep old town of Harlech he could not help photographing it, and in 1920 brought out *The Book of*

Harlech. Two years later he brought out *More Men of Mark*. Among the gay, enthusiastic anecdotes of his introduction there appears this statement:

> *"I believe that most creative artists worthy of the name, of whatever school or medium, be it pen or brush, marble or scale of tones, have an inner world of inspiration which interpenetrates this world of action, and into this sanctuary they may, yea must, at times retire for meditation and refreshment. Some say in sleep this state is reached, and dreams the bringing back of some vague glimmerings to the waking life; but the way is more firm than this, and happy is he who finds the central way."*

But Coburn could not retire to his sanctuary forever: "To see a beautiful thing of any sort, to dance with joy about it, but to hug it to one's self and never tell another, is fantastic and unthinkable, and leads only to stagnation and artistic indigestion." So Coburn came back into the world. Not however, to the art world. The shock tactics of the Surrealists were the antithesis of his own approach. He was not aware of what was happening in America: of what Stieglitz, who also chose what he called "the affirmation of life," was doing in his hundreds of photographs of one beloved woman, Georgia O'Keeffe, and in his photographs of clouds, which he at first conceived as music and later called "Equivalents"—symbols of complex emotional experience. Steichen, after the analytical sharpness necessary to aerial photography, was now photographing a matchbox or a cup and saucer over and over again, until he mastered the permutations possible to Straight Photography; then, realizing how little art in any form had ever paid him, went into commercial and illustrative photography.

Of the younger generation Coburn probably knew very little beyond what he had seen of Paul Strand in the last *Camera Work*, and of Edward Weston up to 1917 in the London Salons. Little or nothing of their new work was appearing in the magazines. Nor was he aware of the work of the young American painter and photographer Man Ray in Paris, and the young Hungarian painter and photographer Moholy-Nagy in Germany.

So Coburn pursued mysticism as ardently as, for seventeen brilliant years, he had pursued photography.

Plates

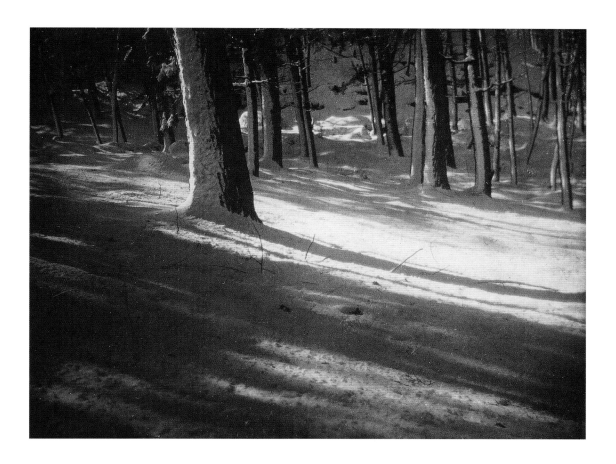

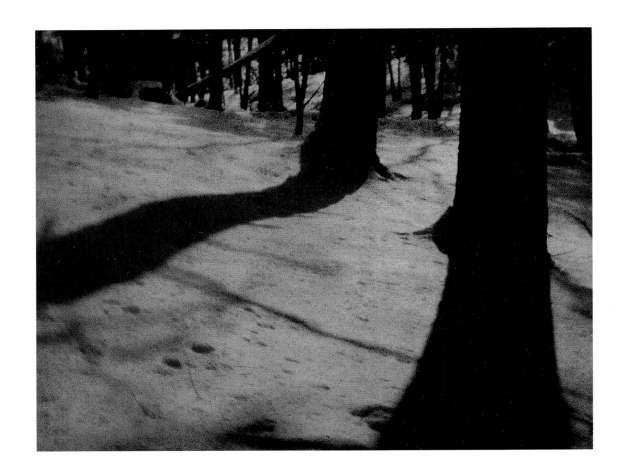

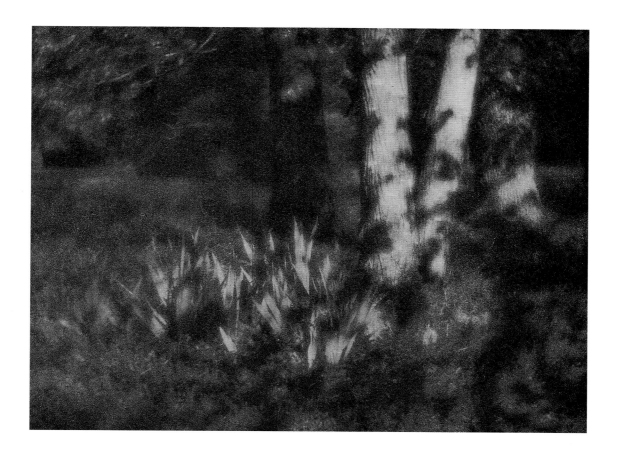

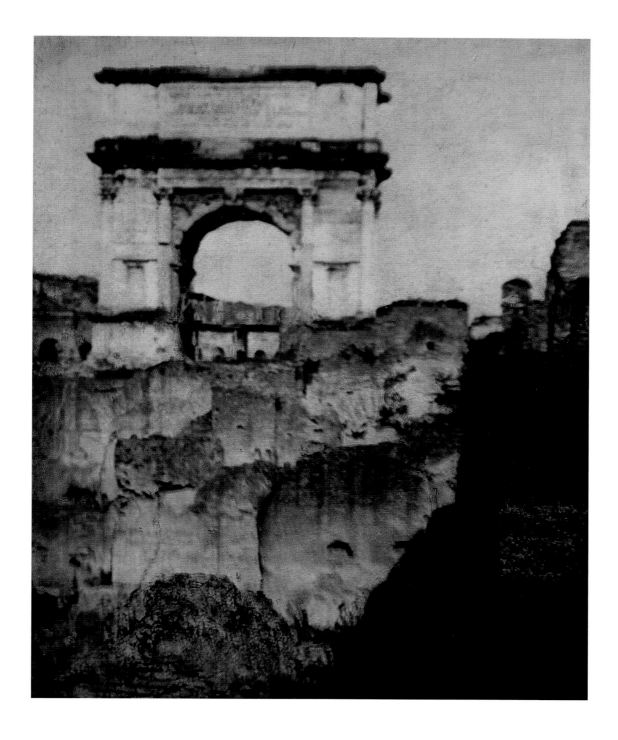

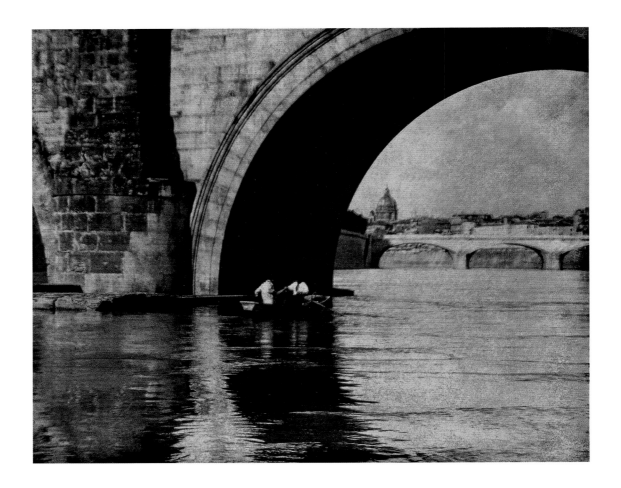

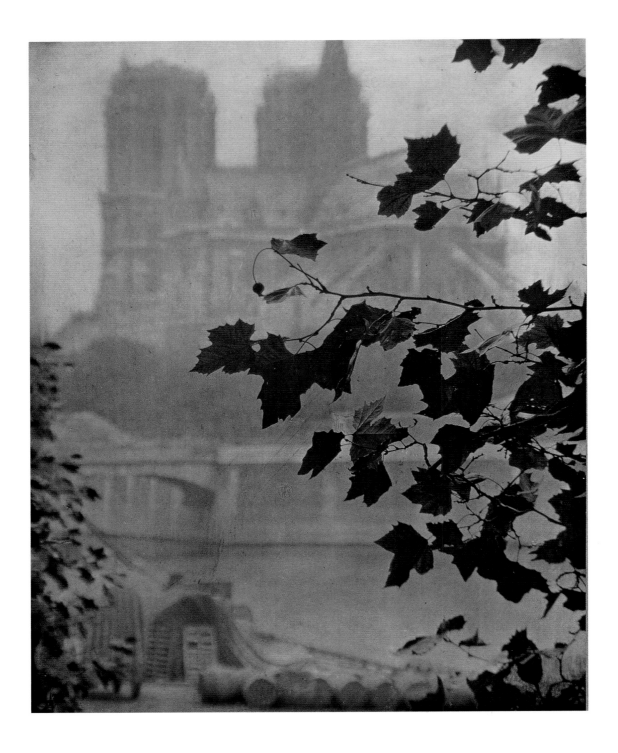

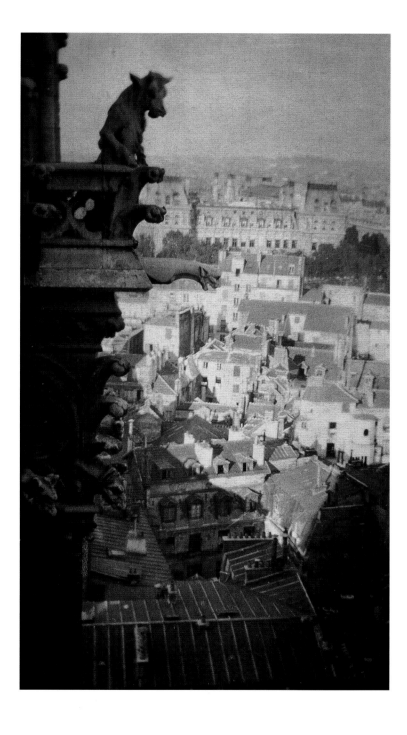

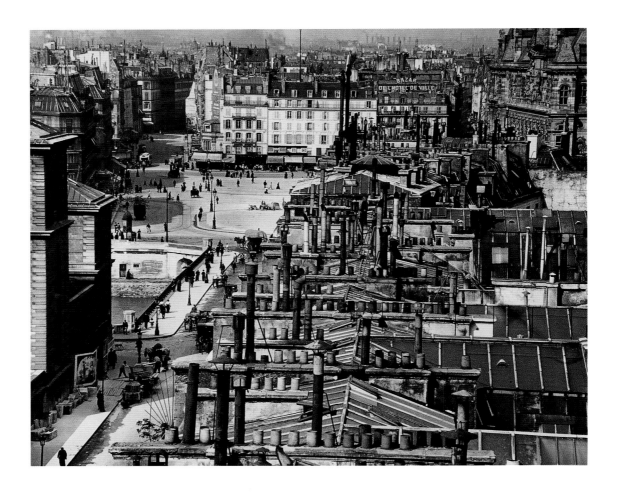

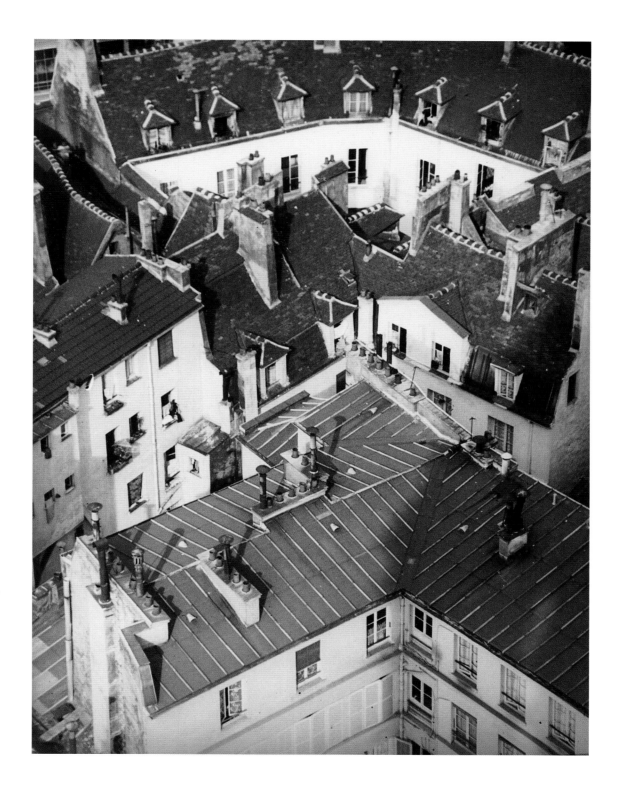

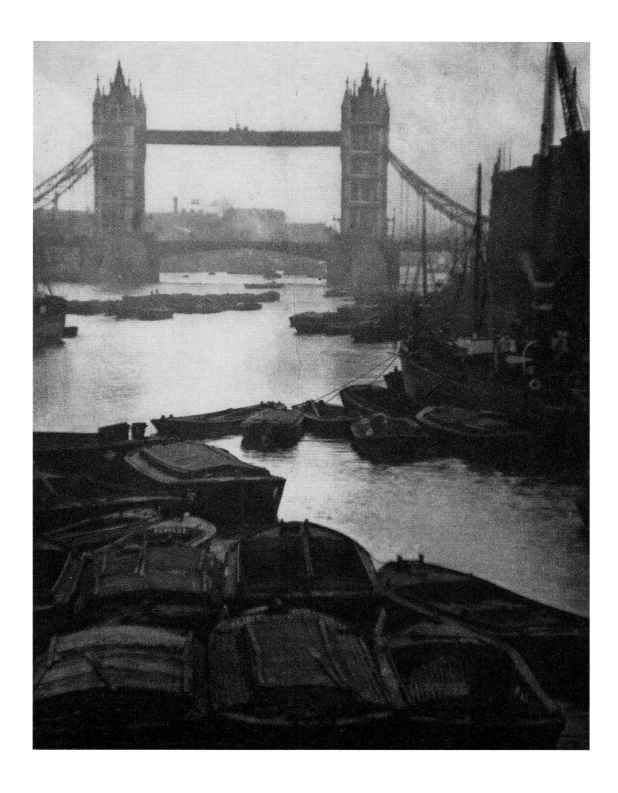

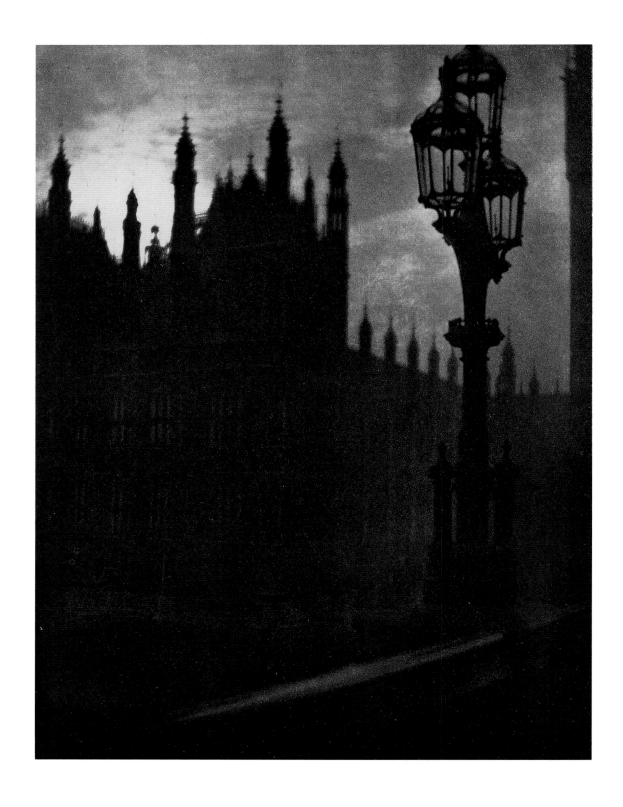

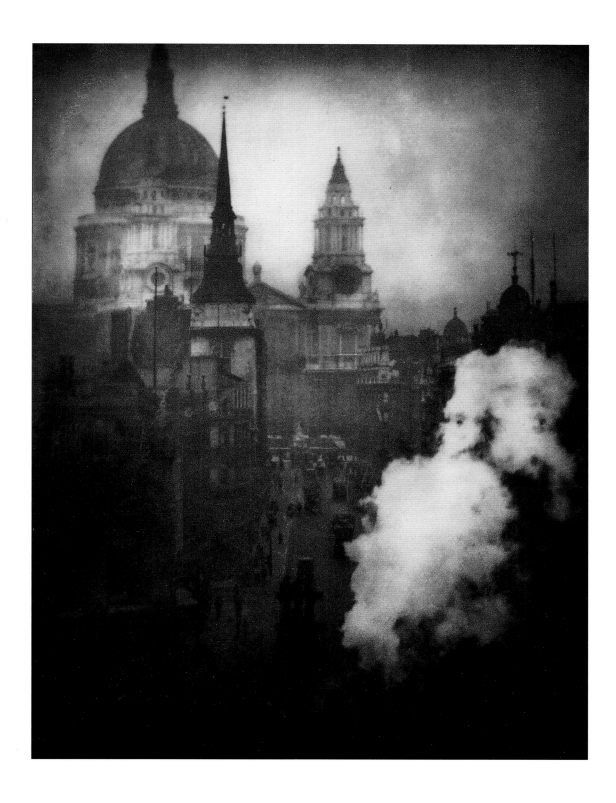

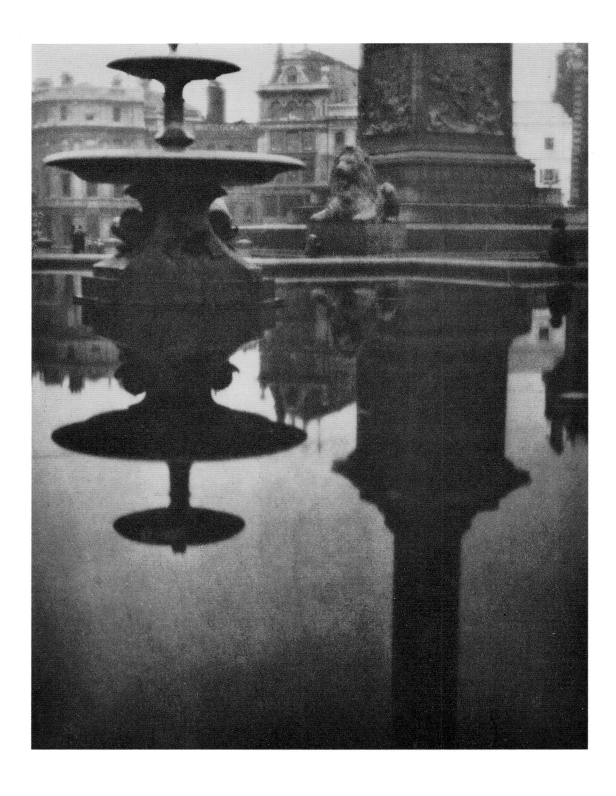

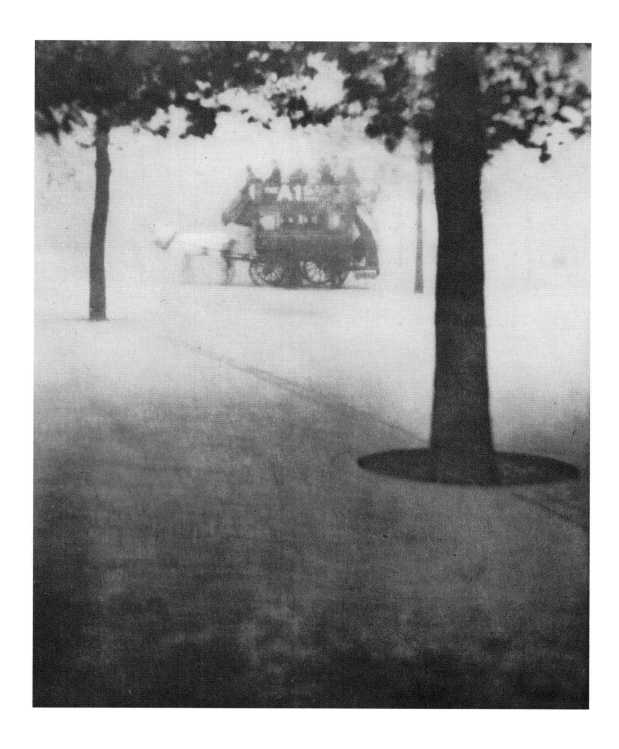

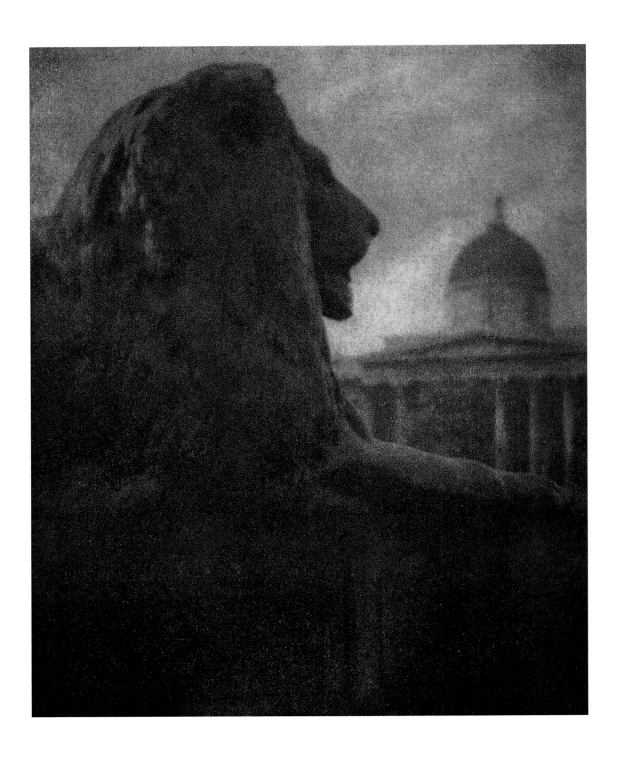

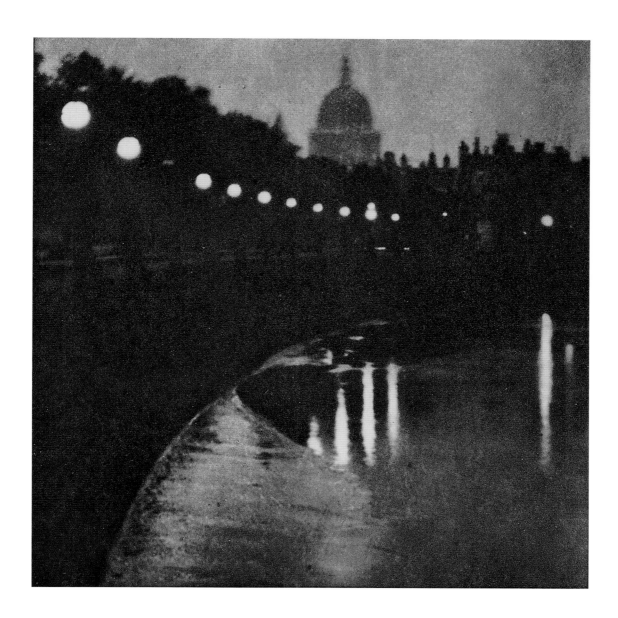

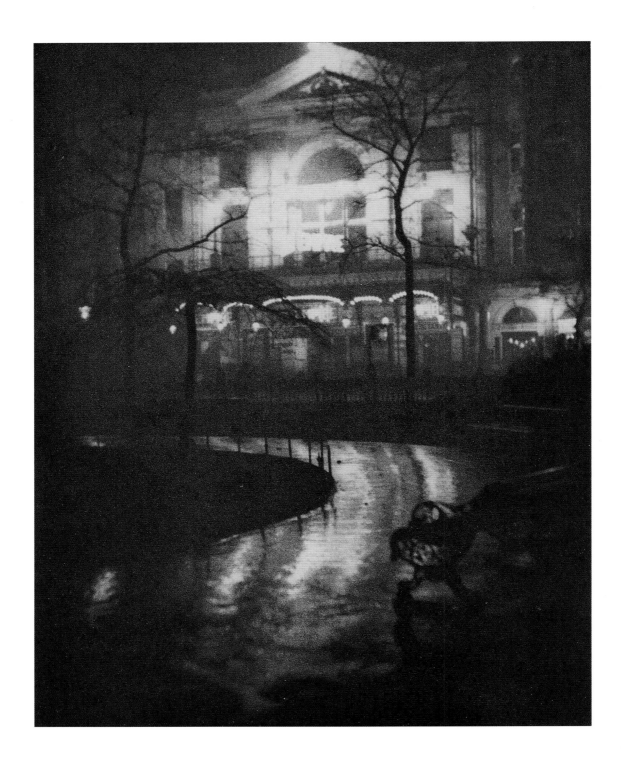

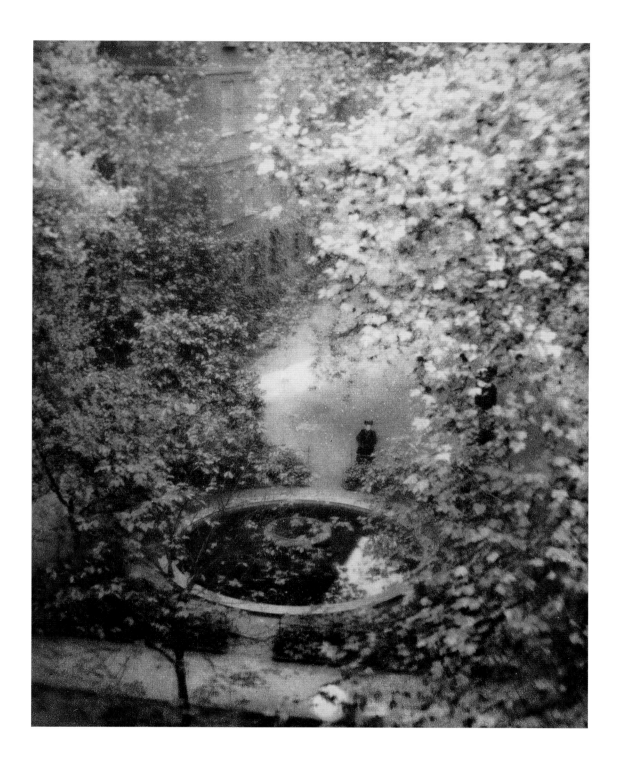

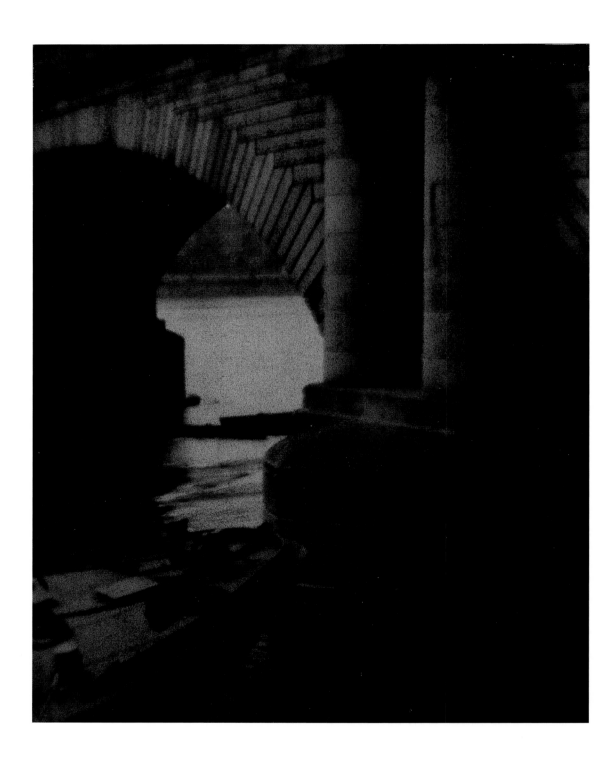

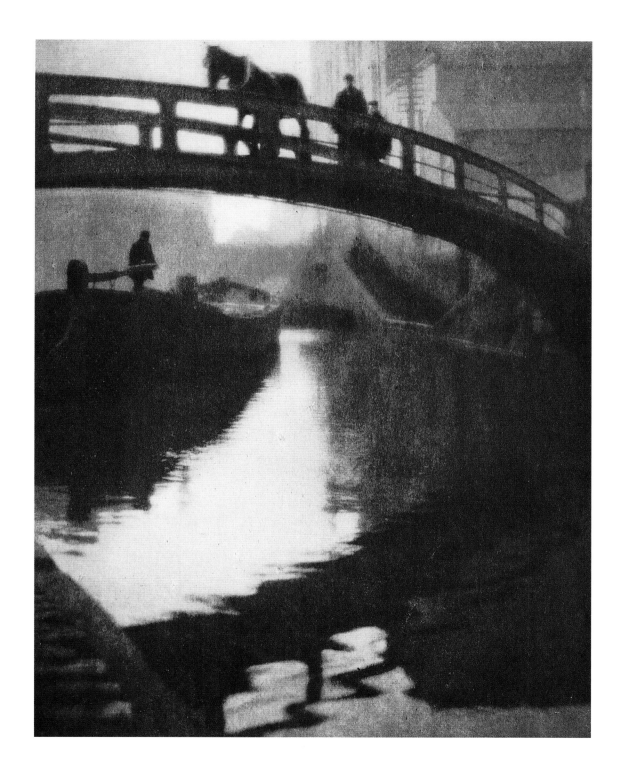

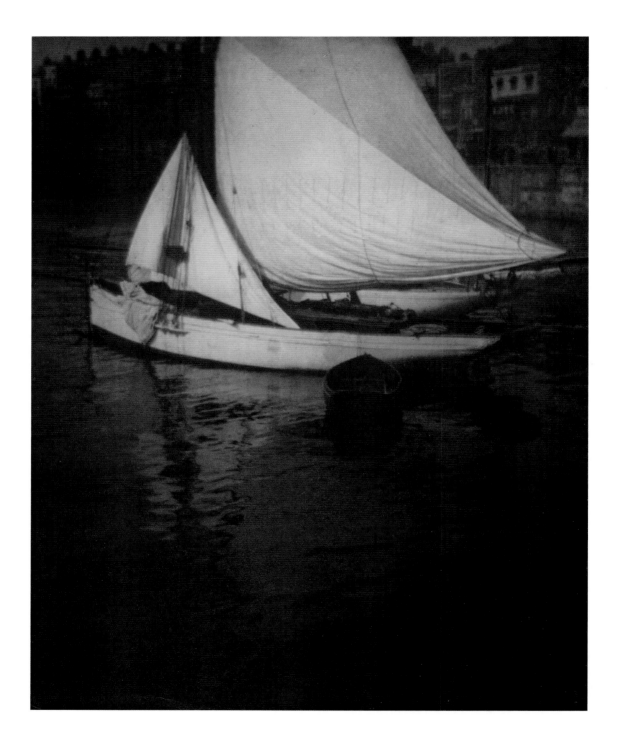

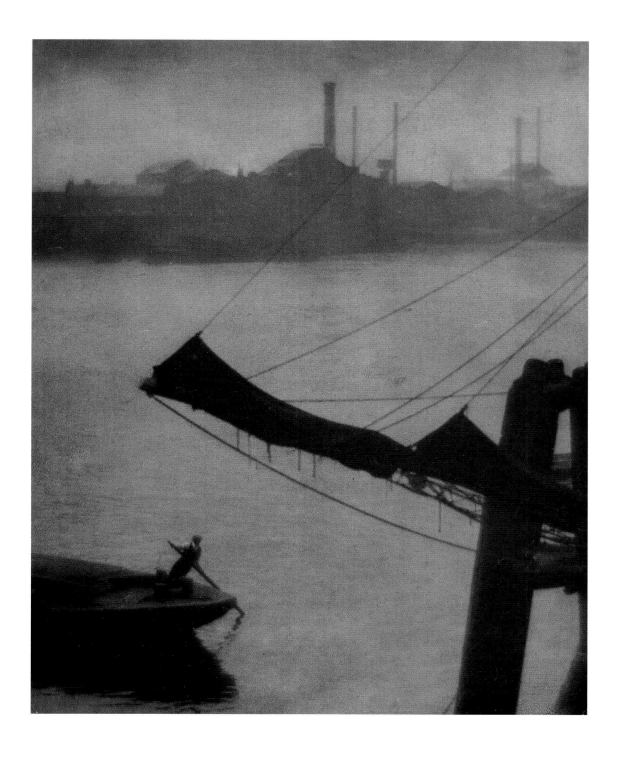

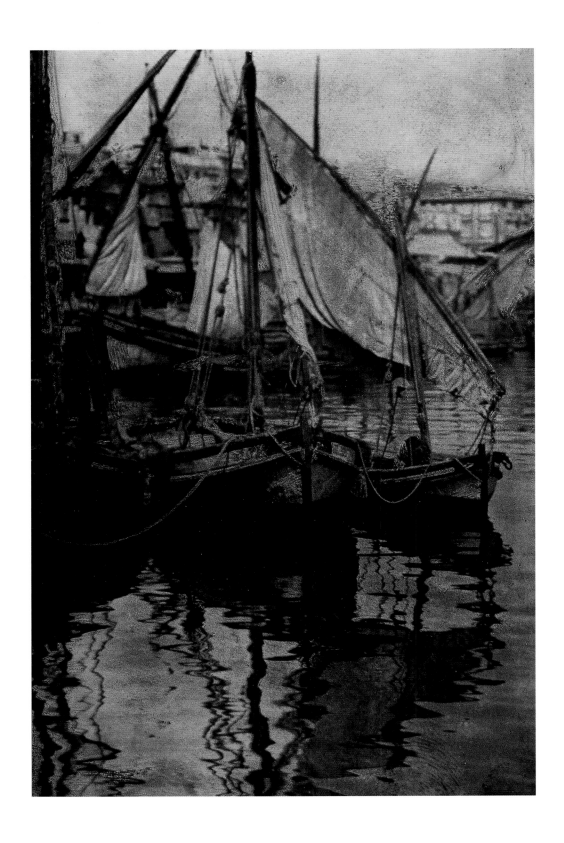

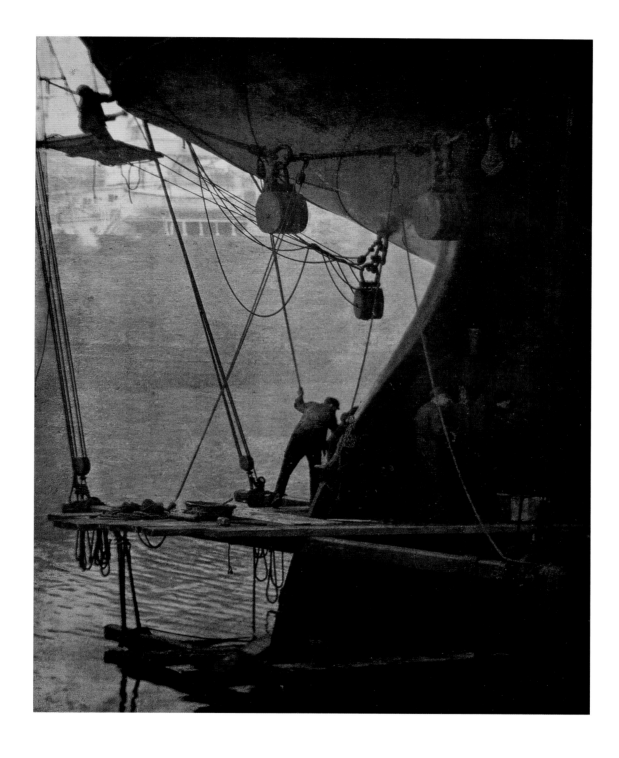

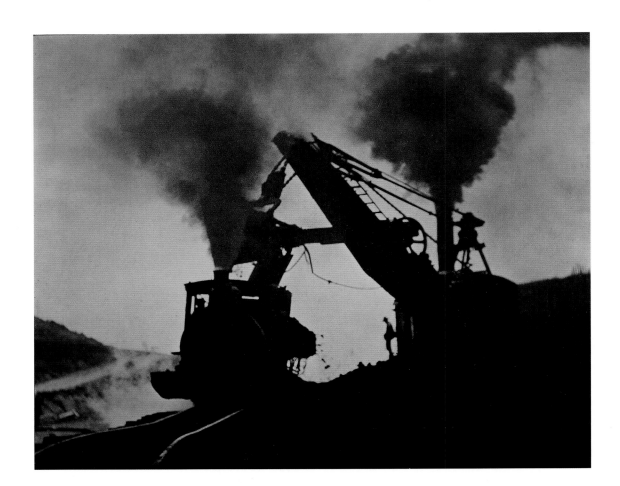

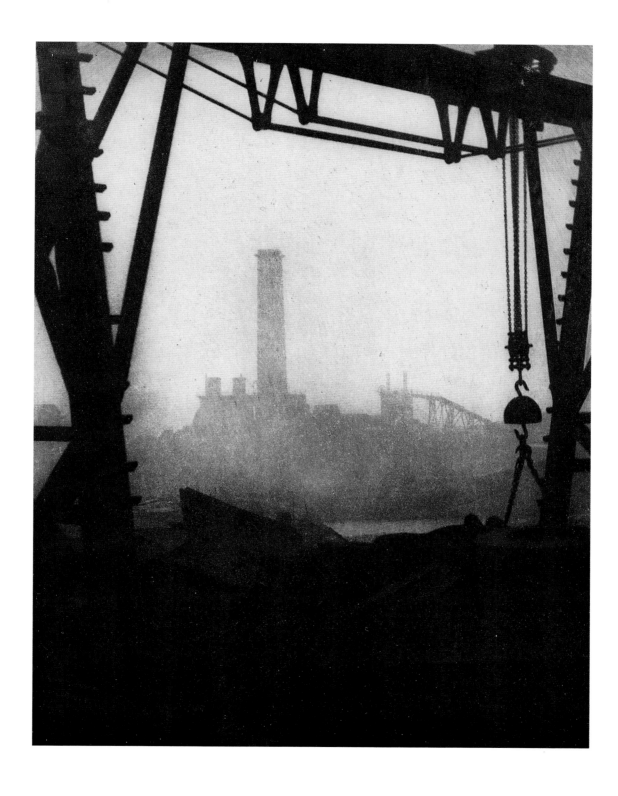

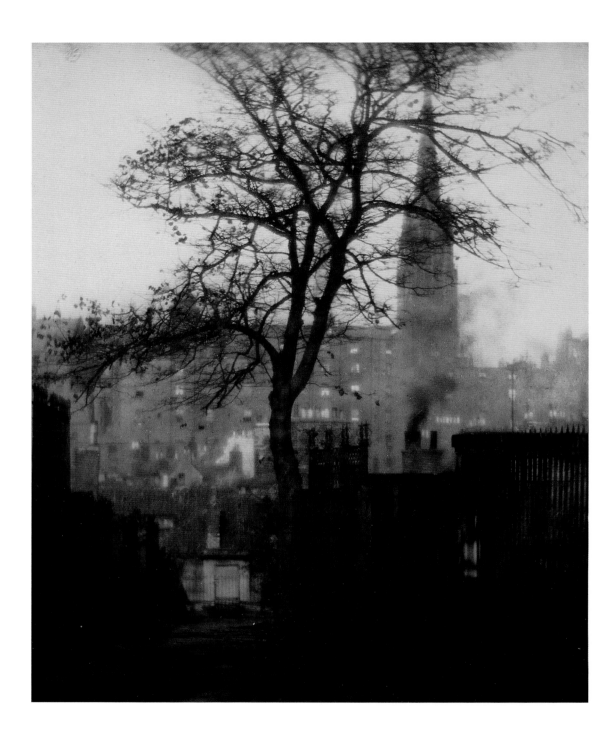

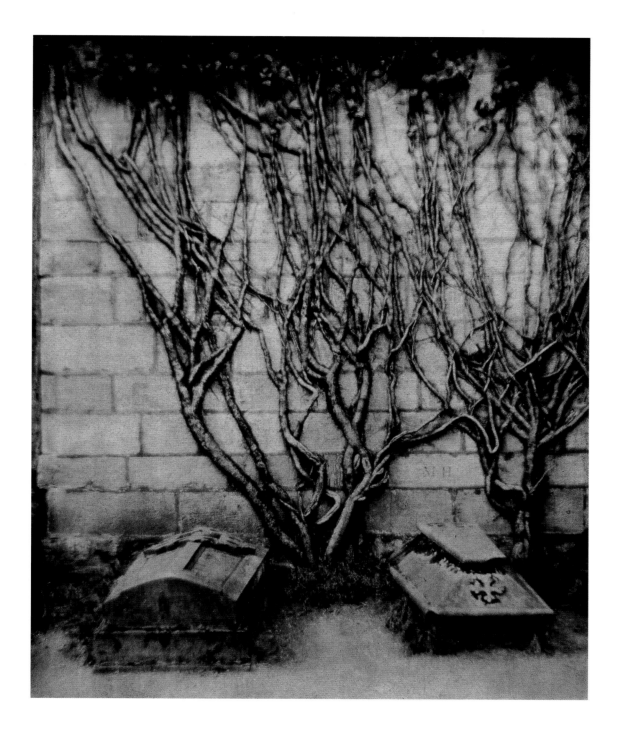

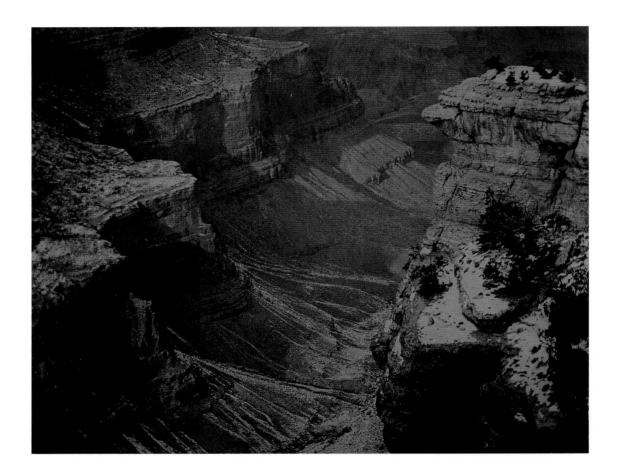

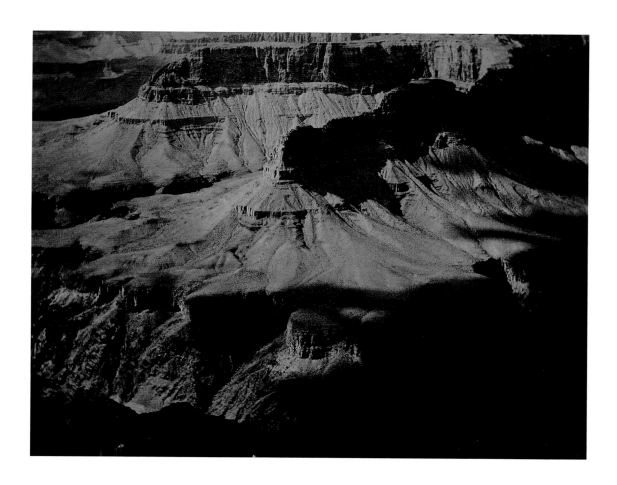

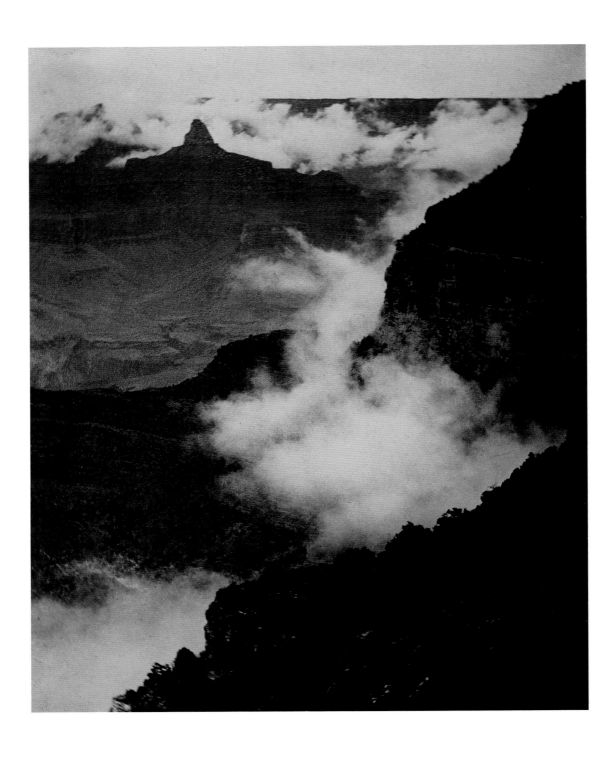

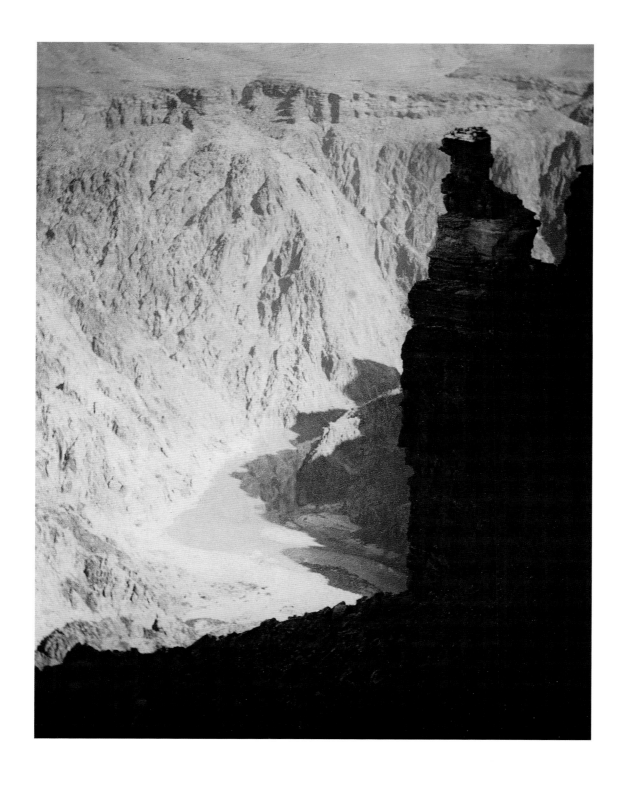

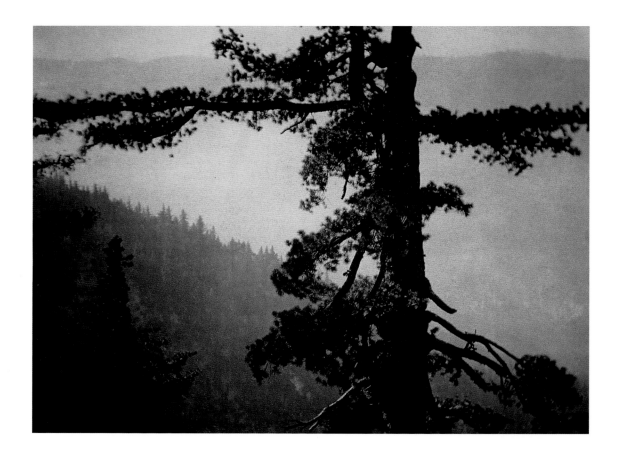

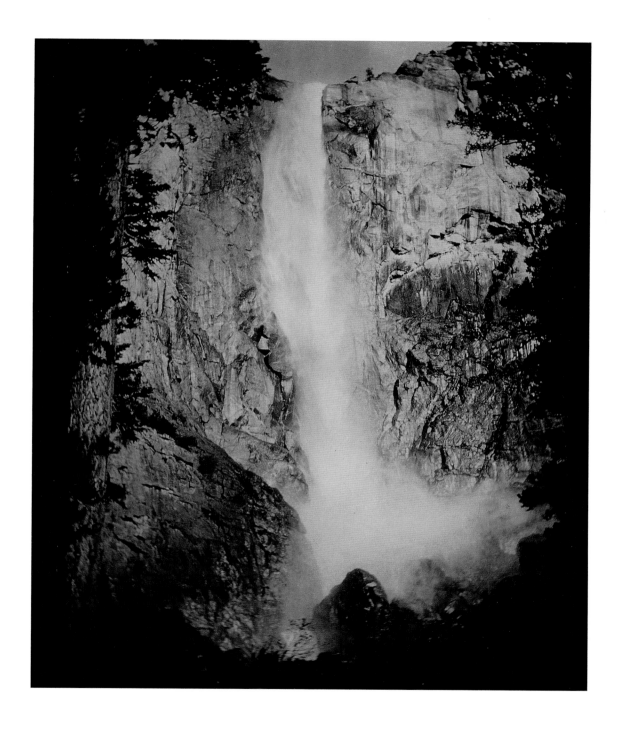

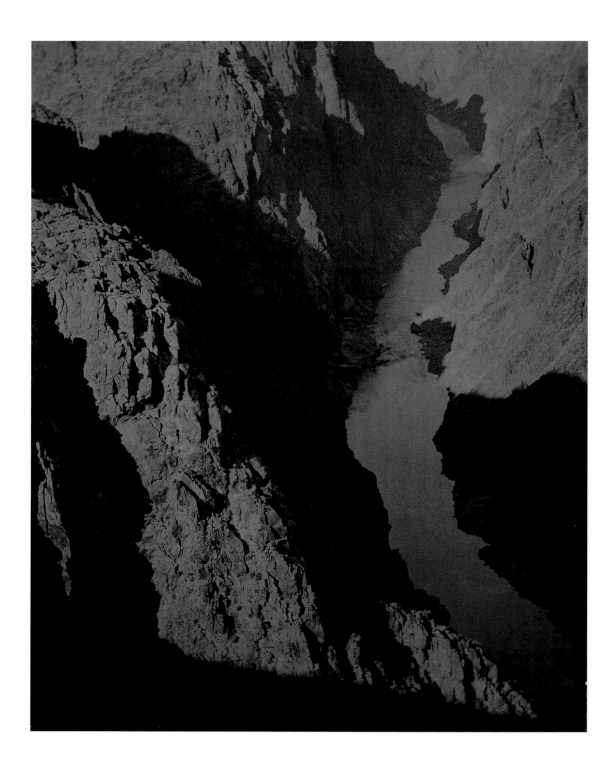

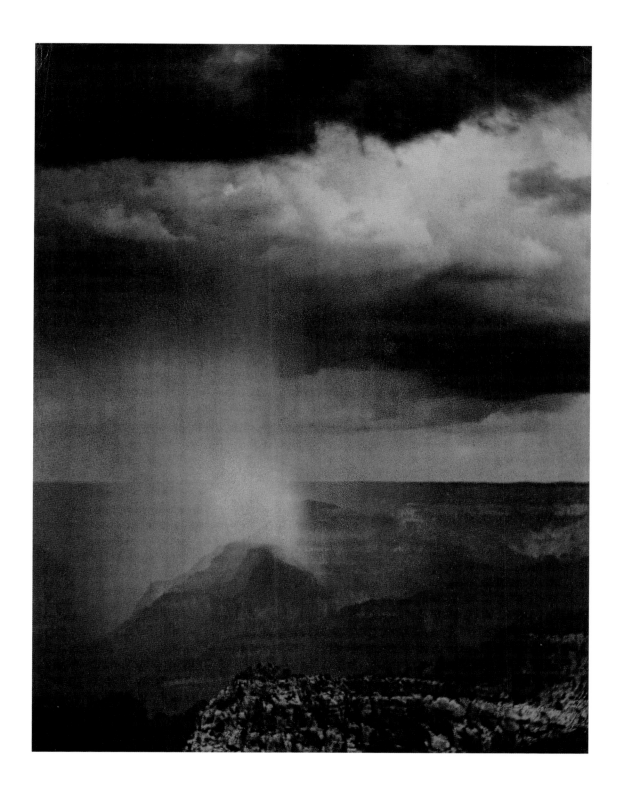

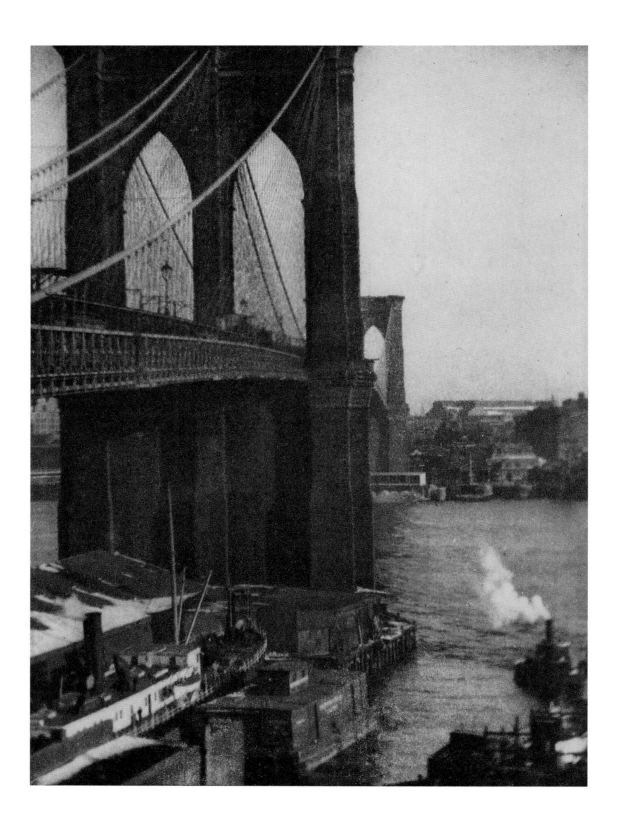

The Flat Iron Building, Evening
New York 1912

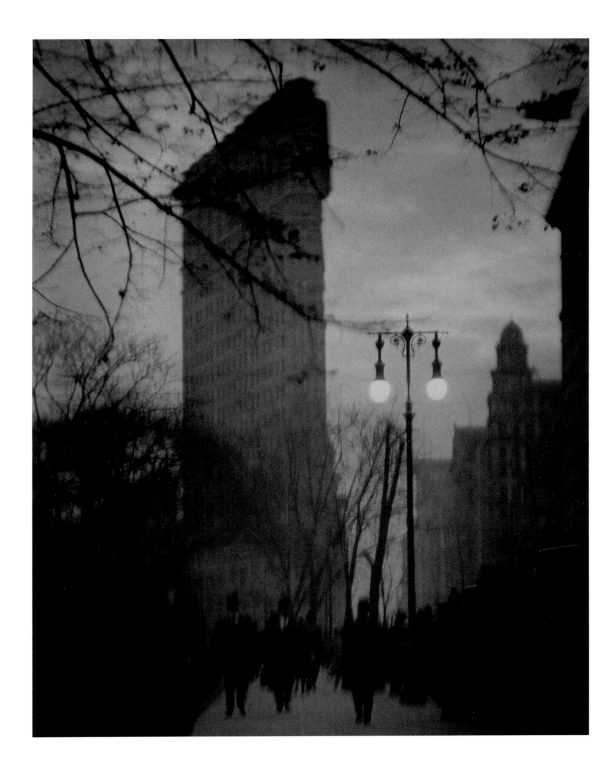

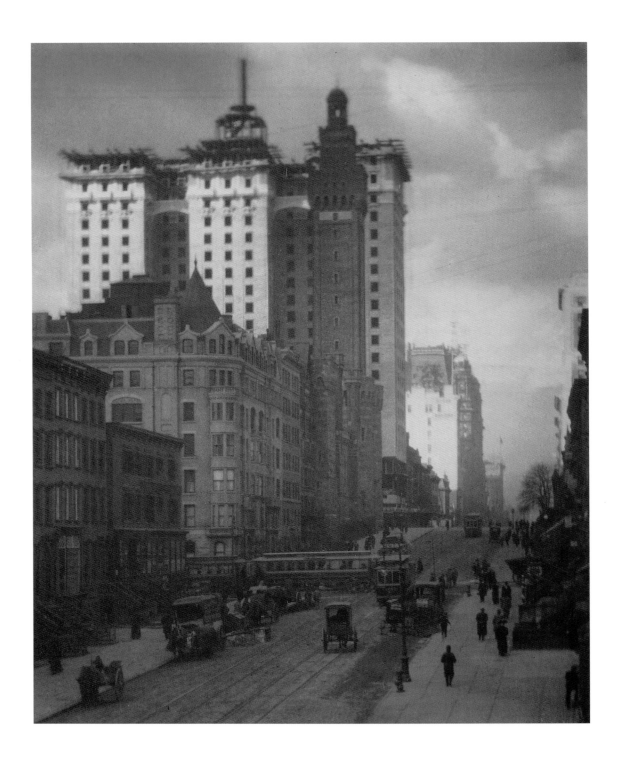

Fifth Avenue from the St. Regis
New York ca. 1905

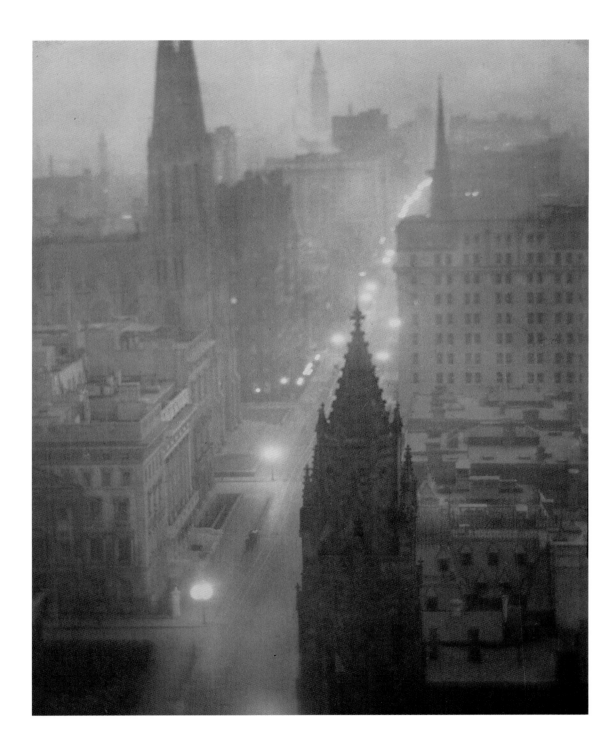

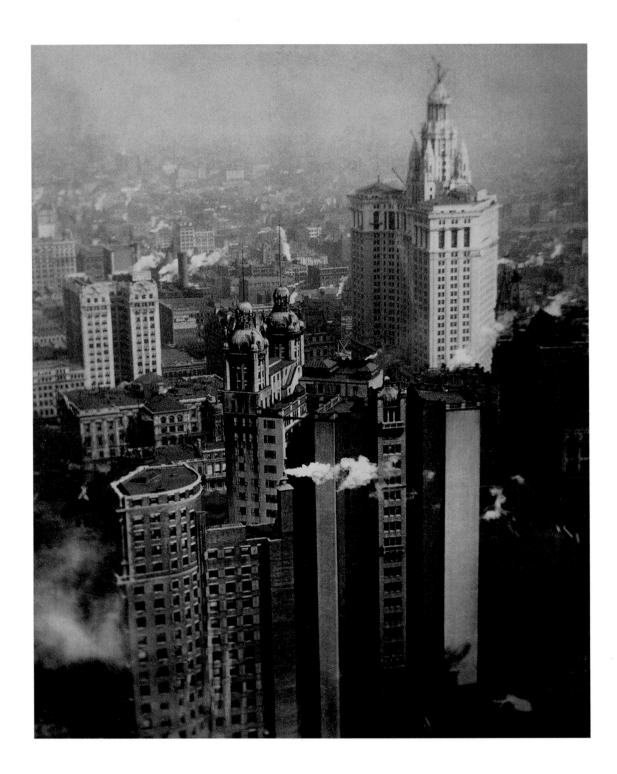

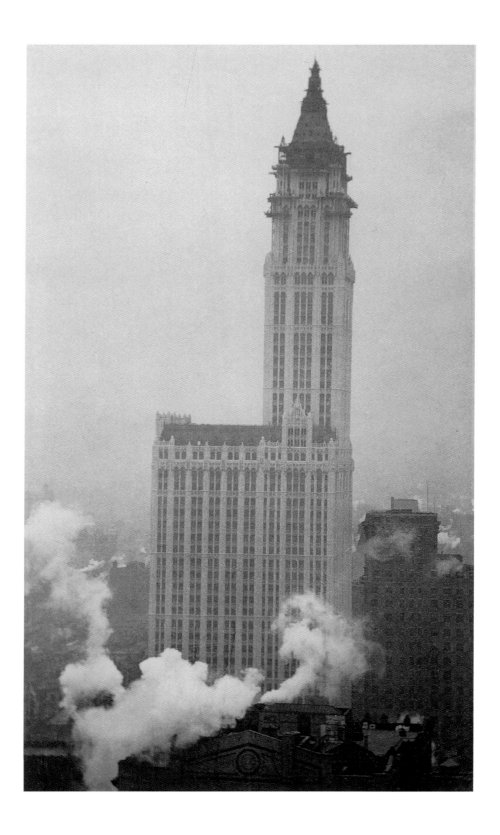

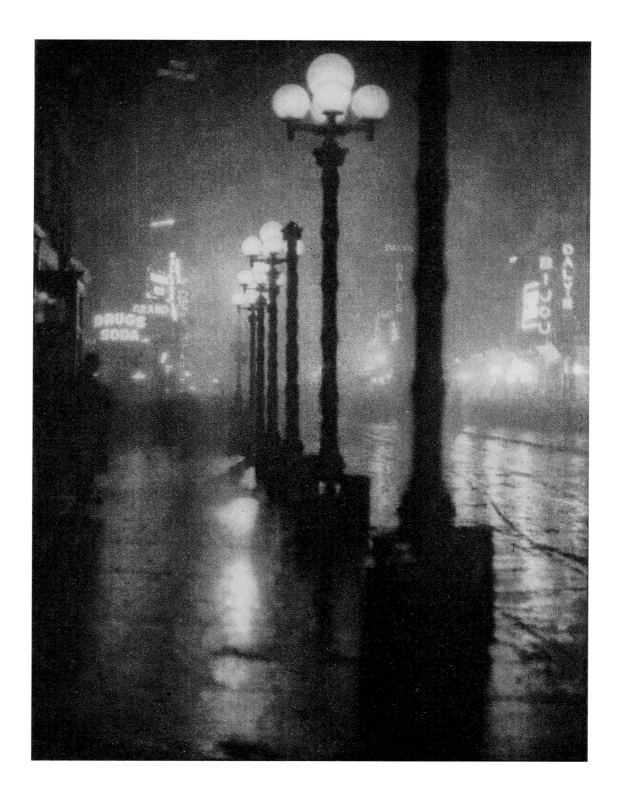

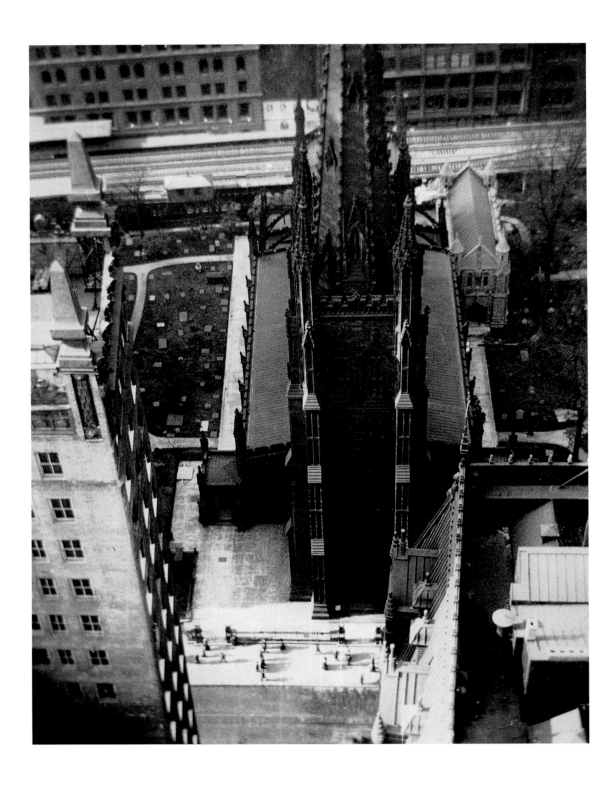

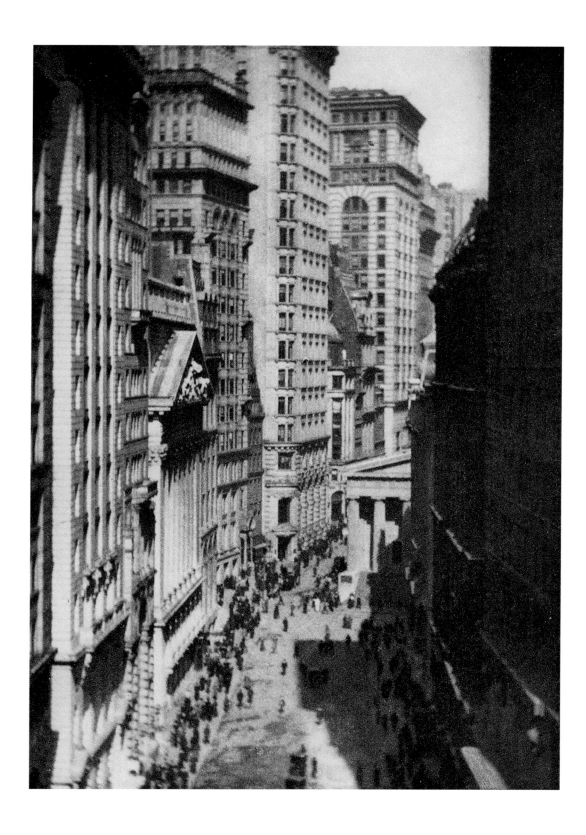

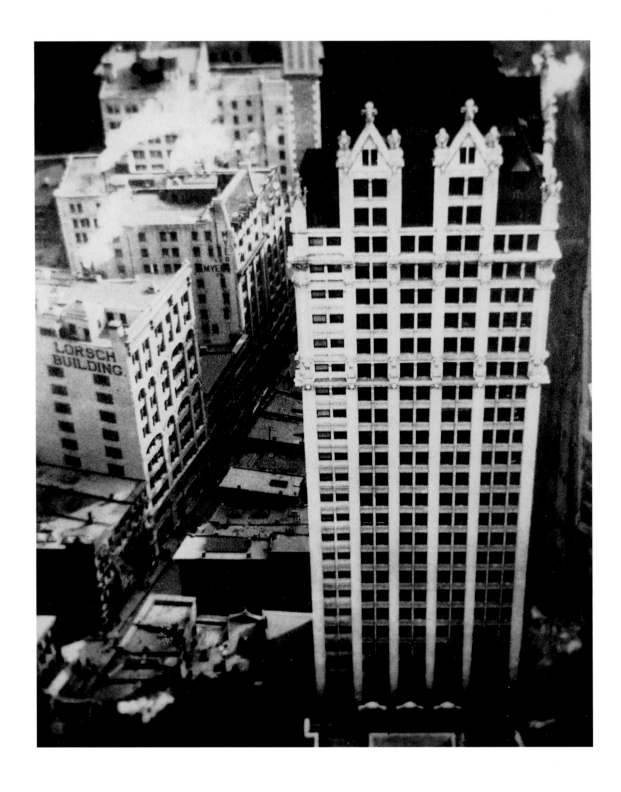

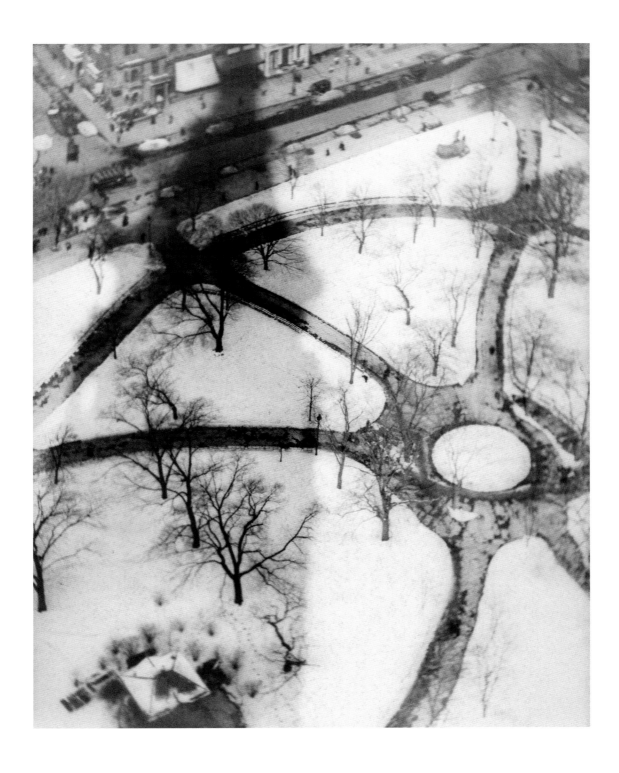

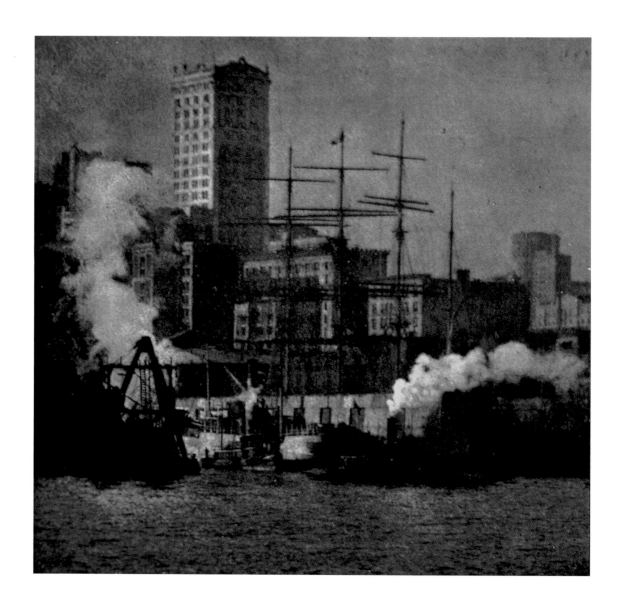

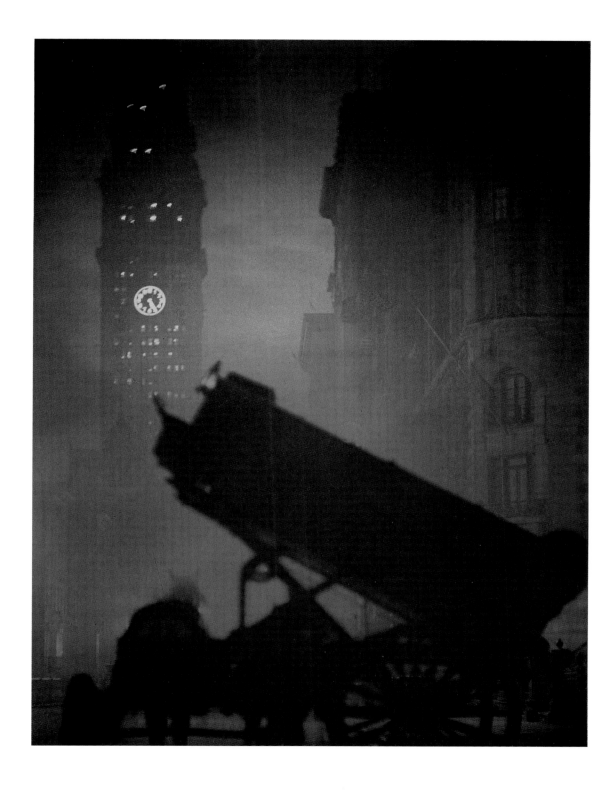

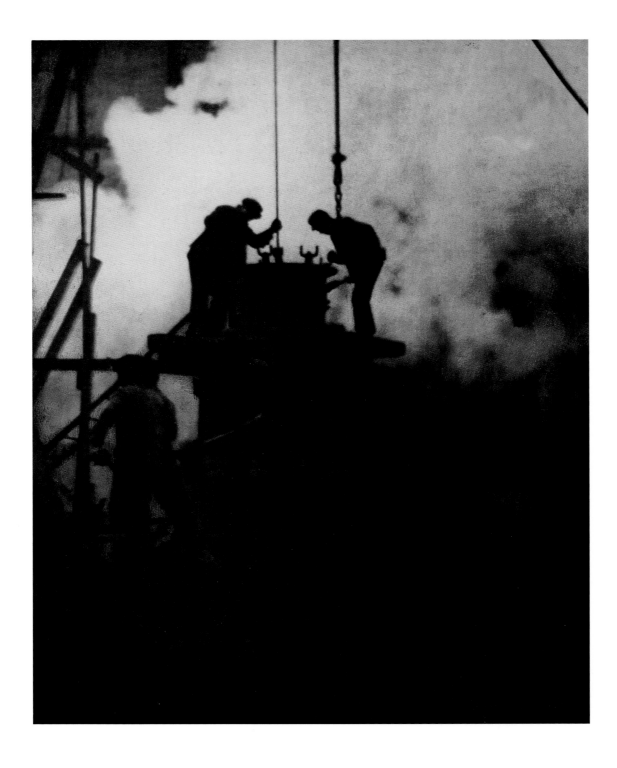

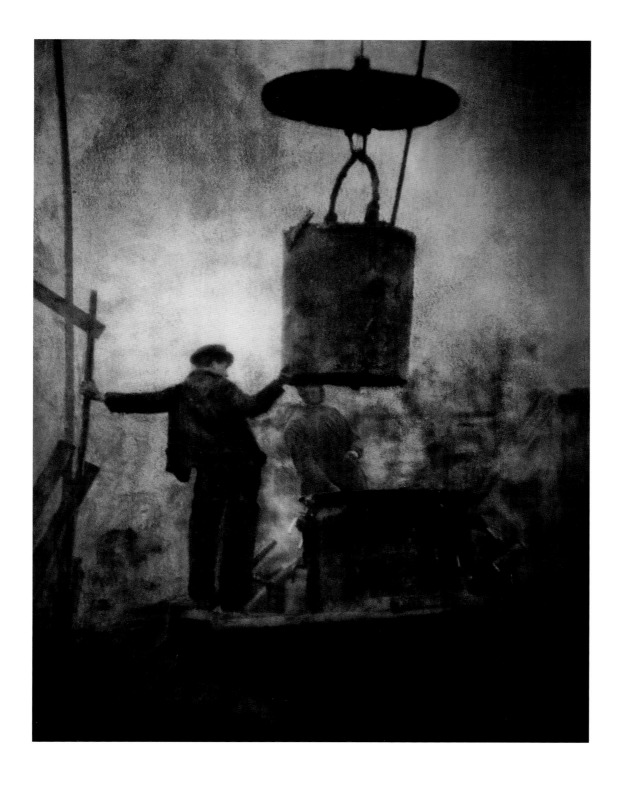

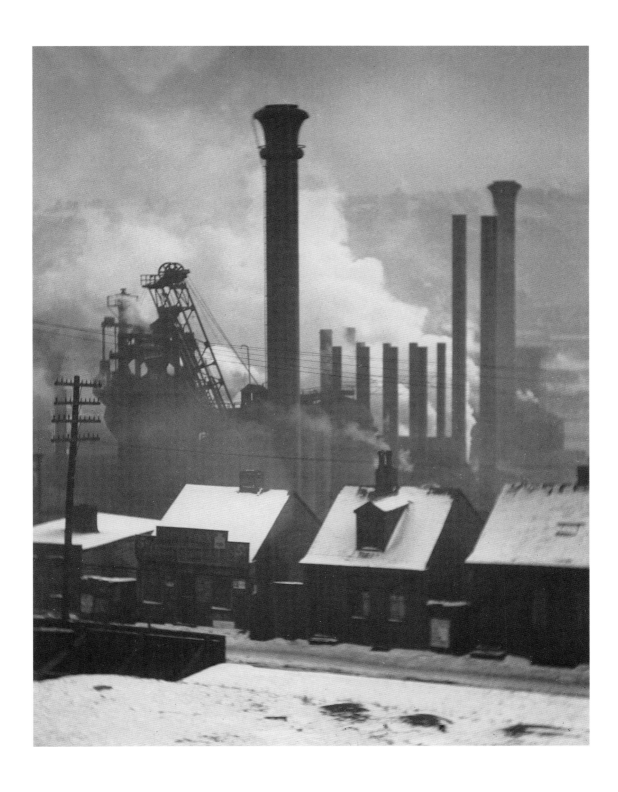

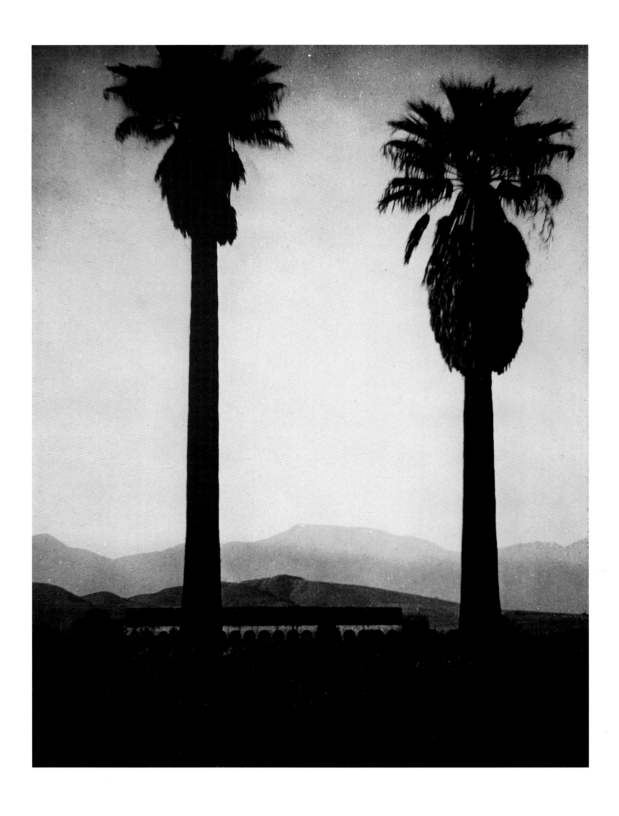

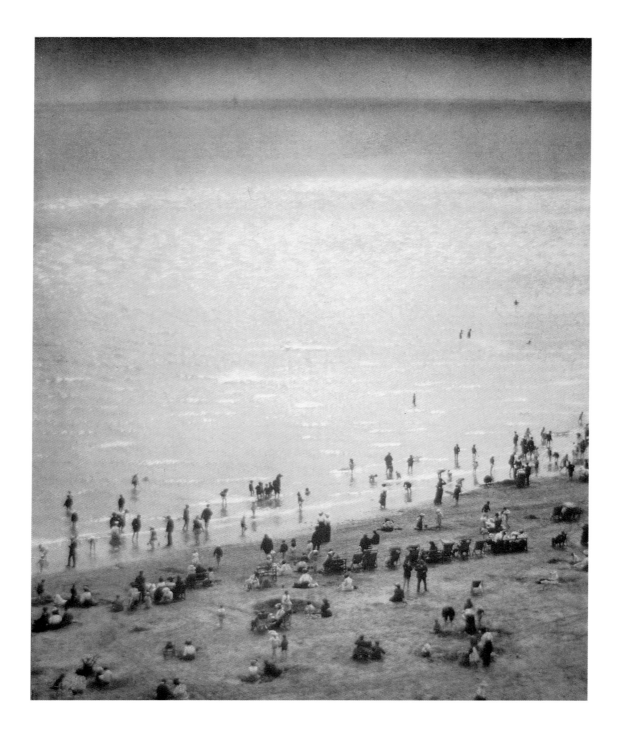

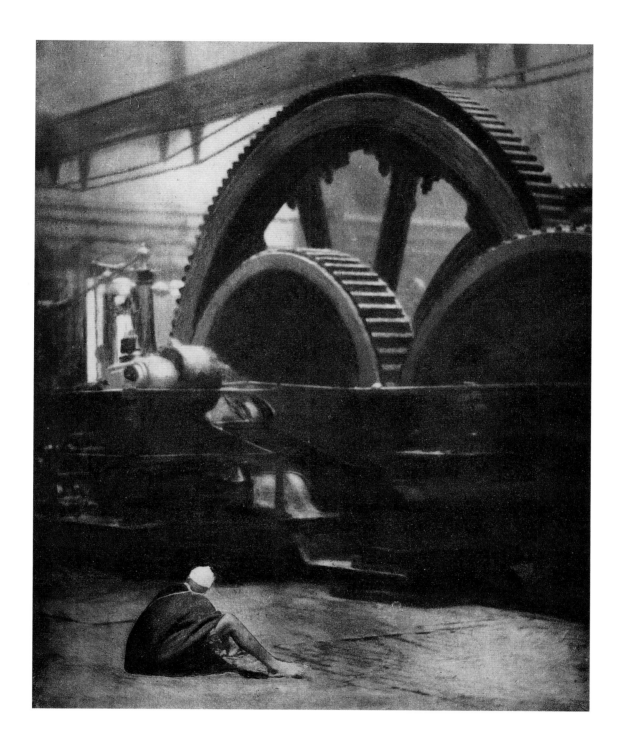

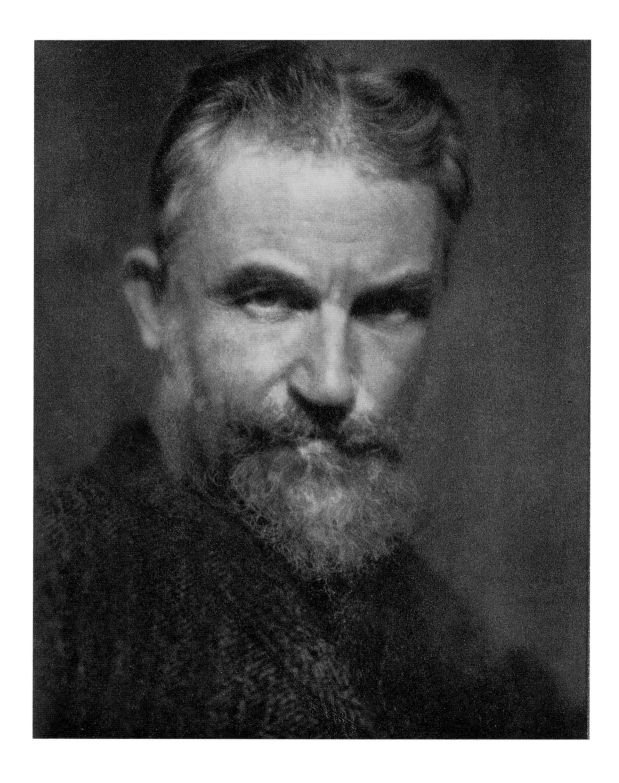

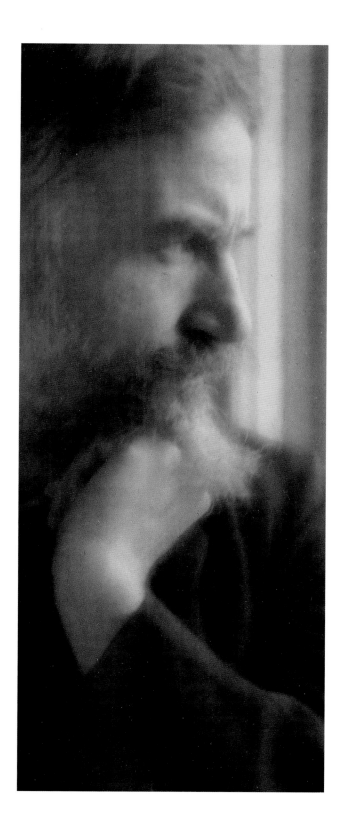

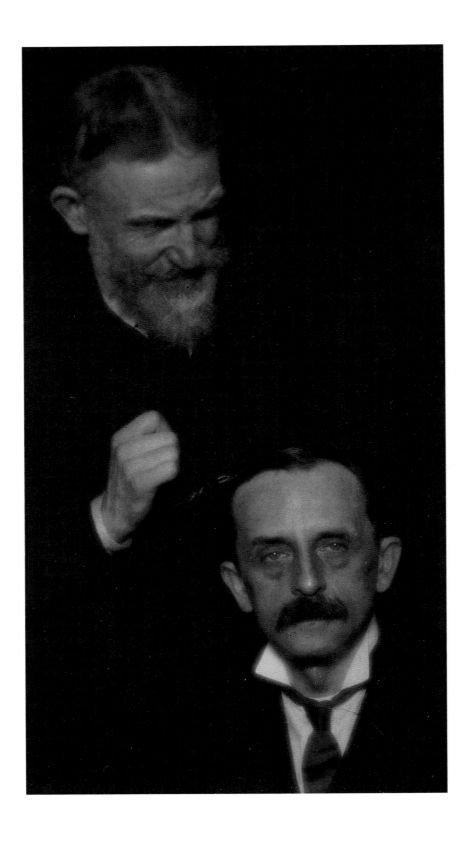

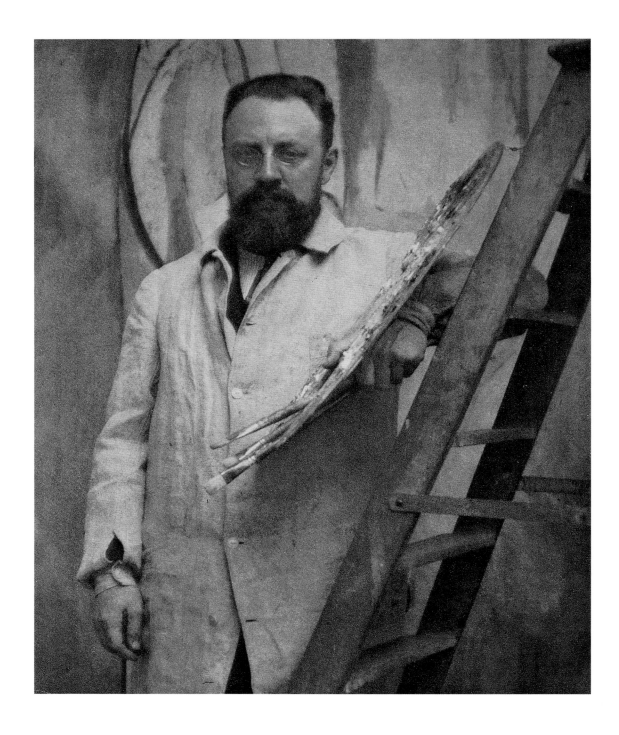

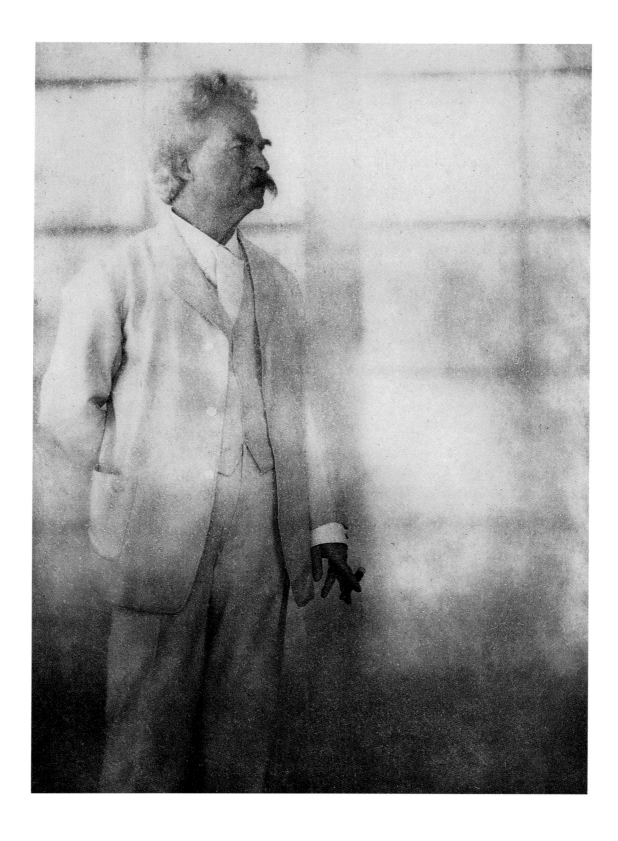

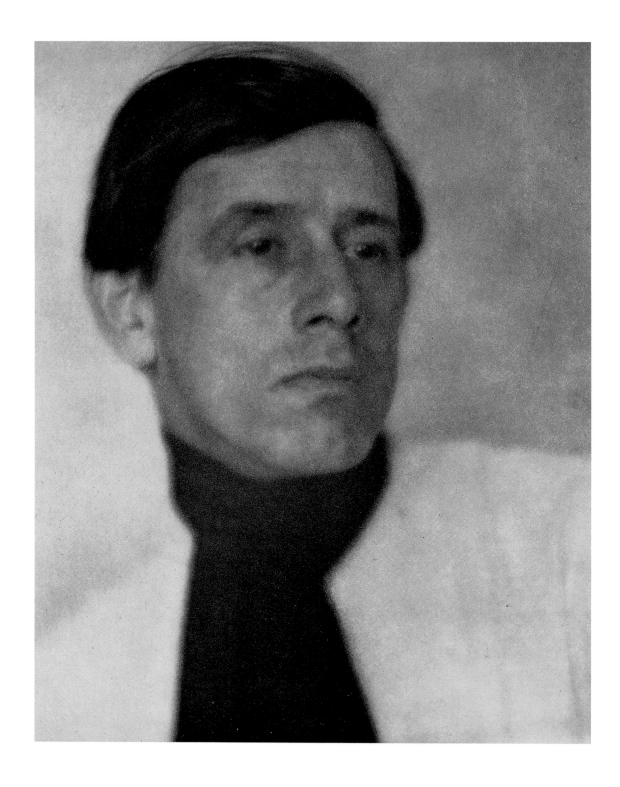

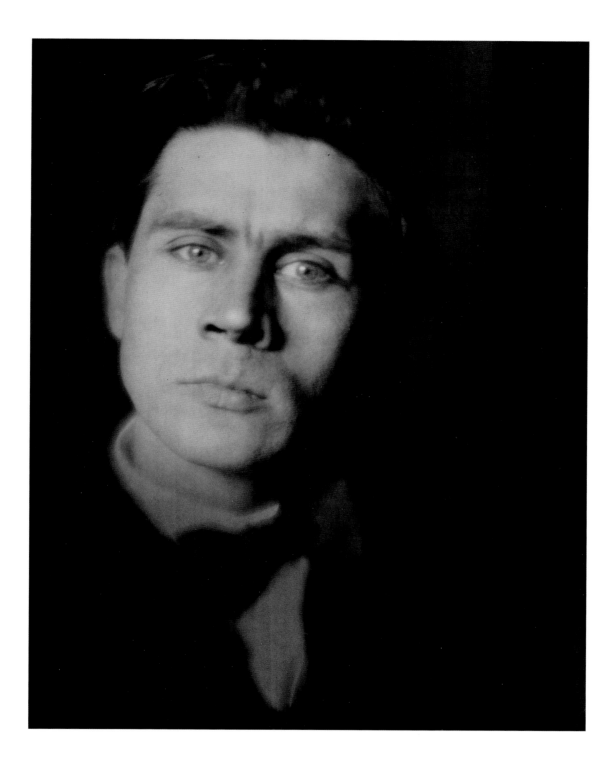

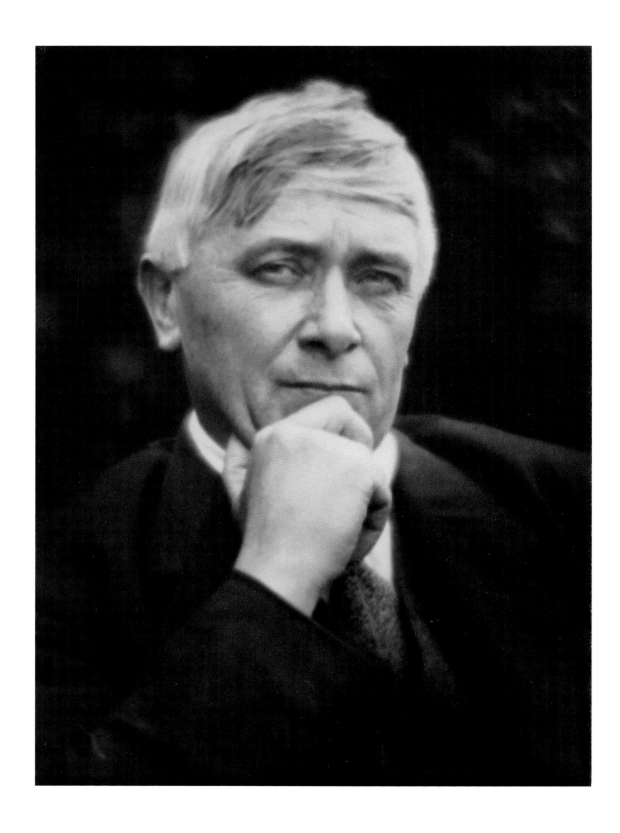

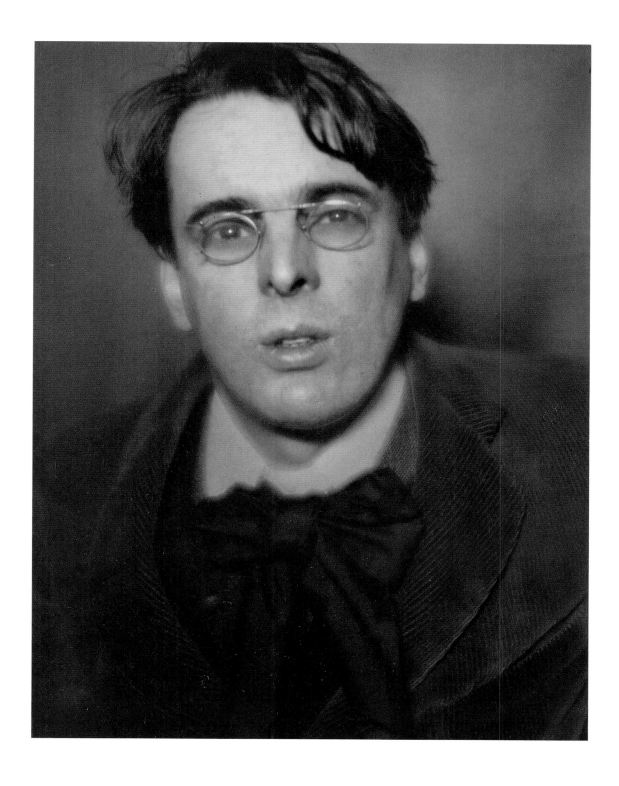

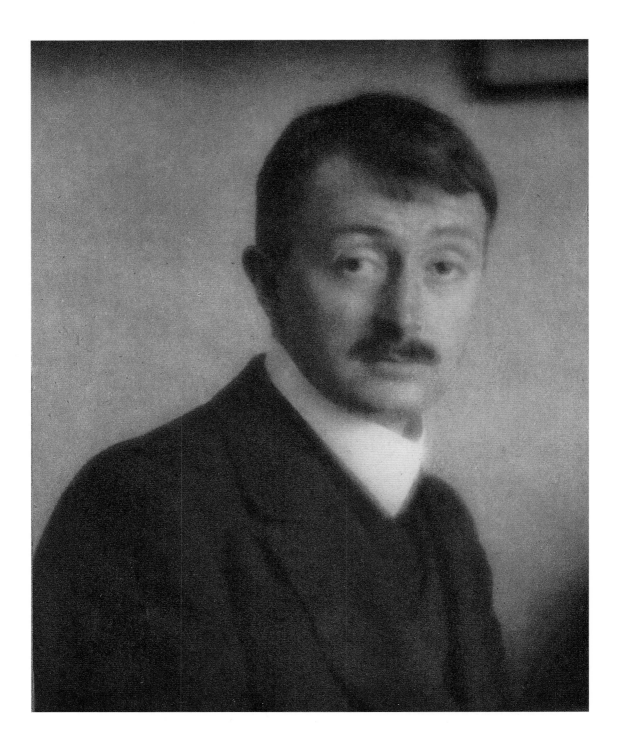

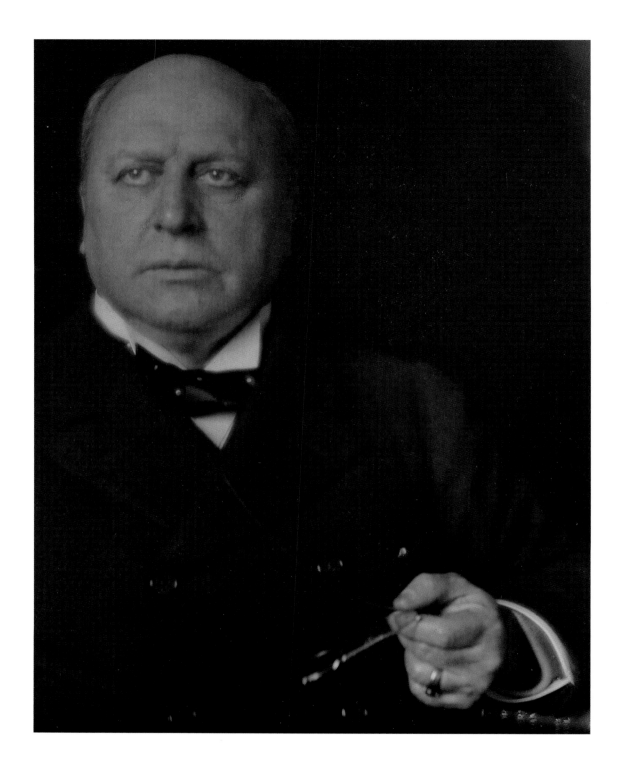

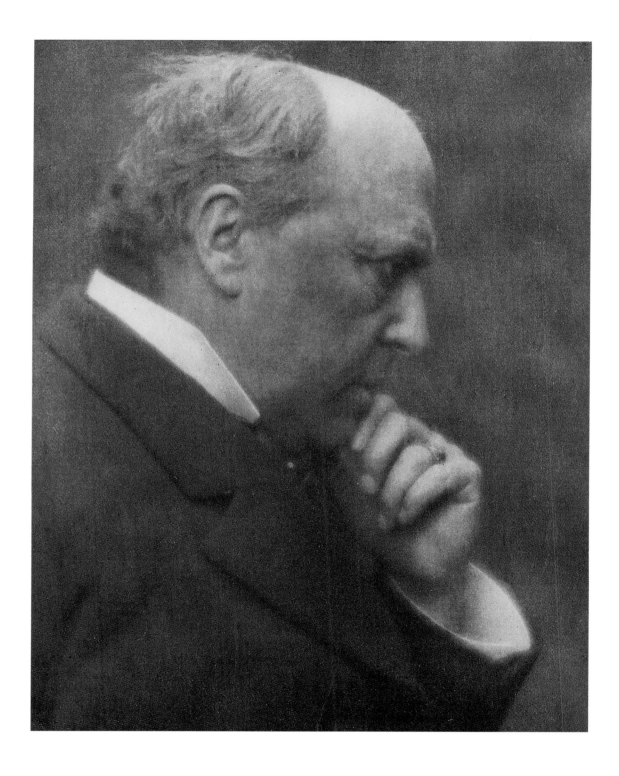

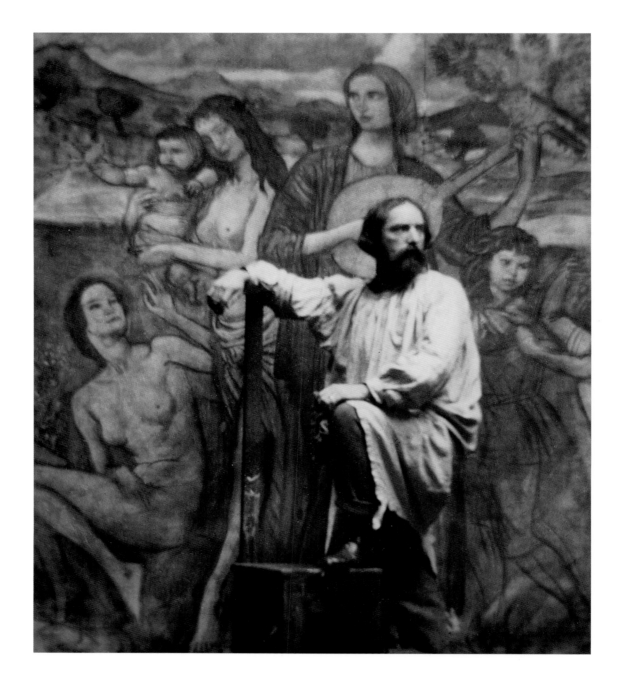

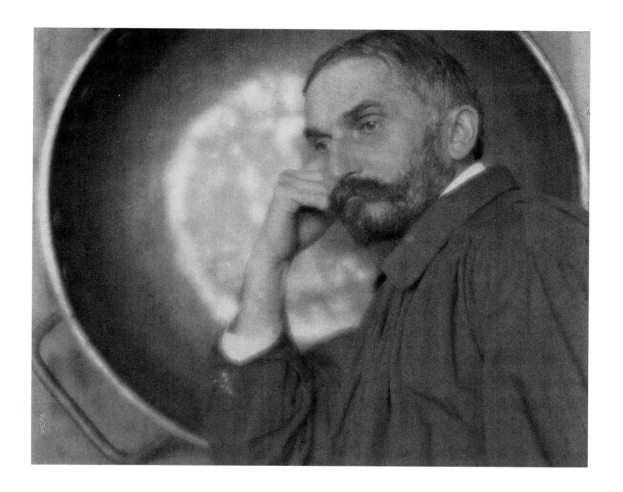

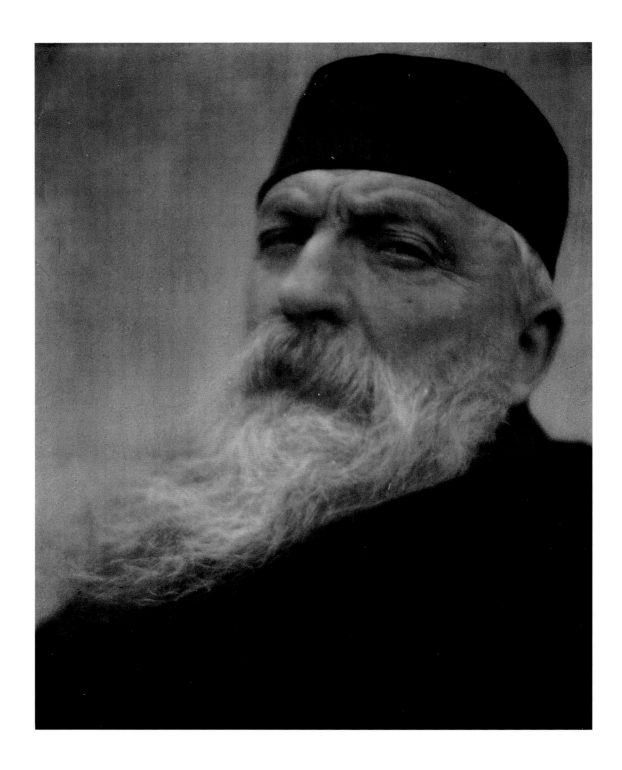

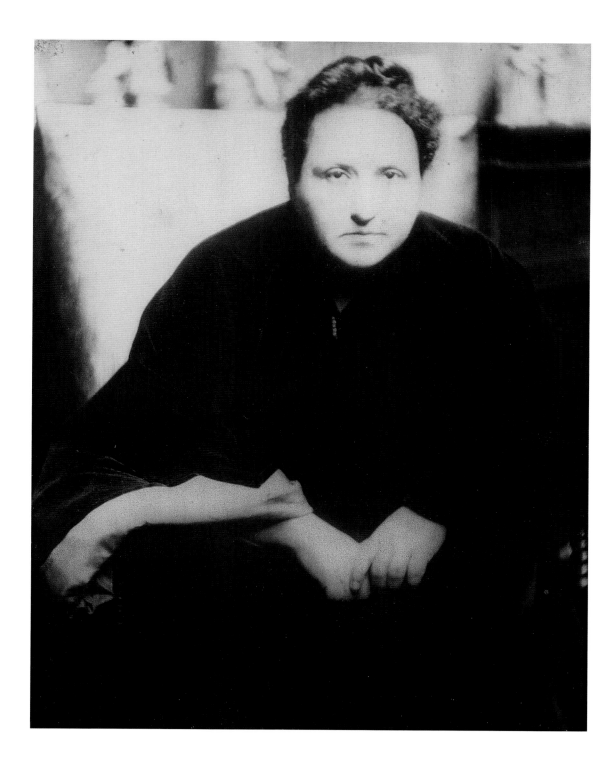

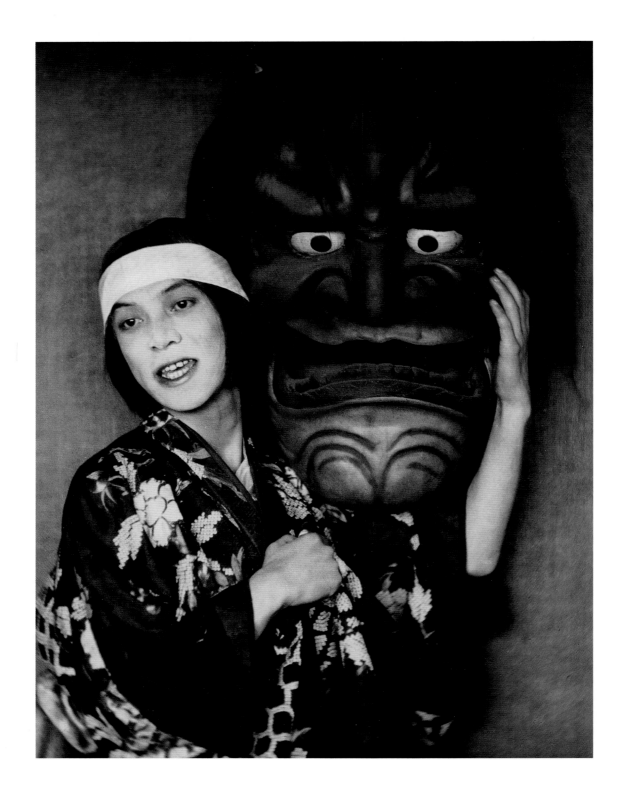

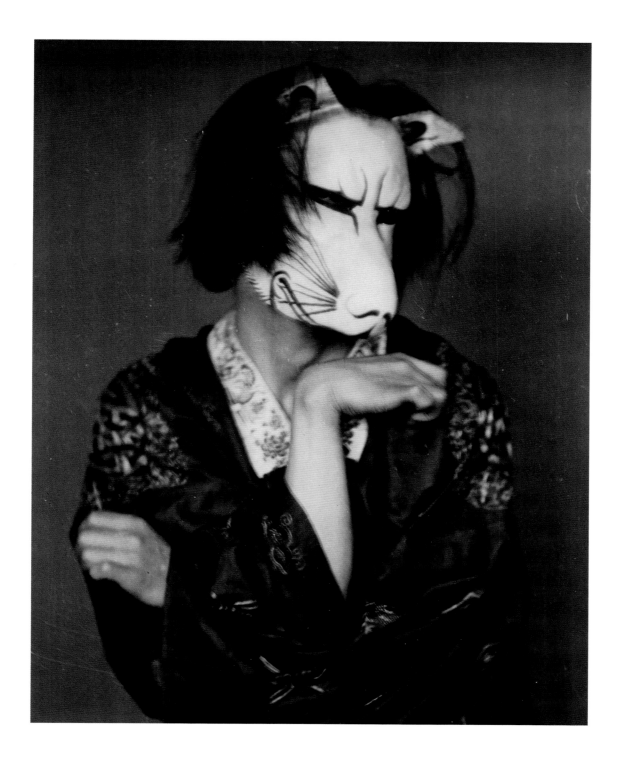

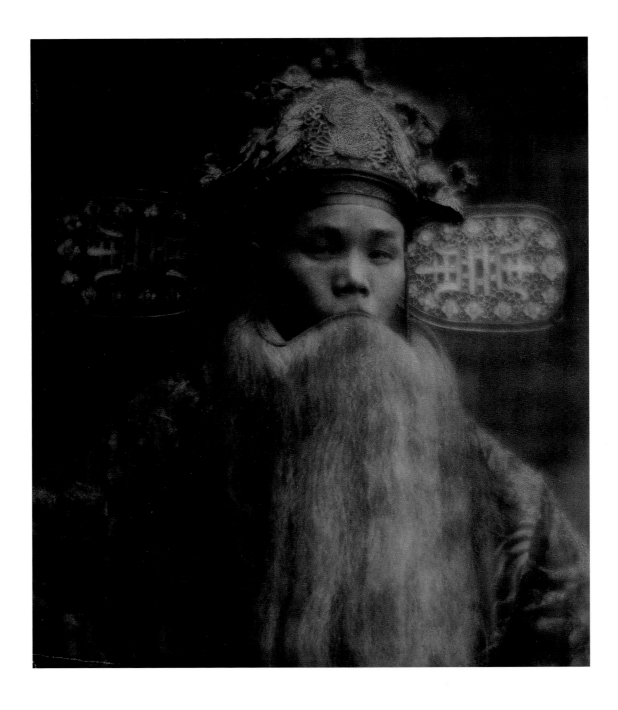

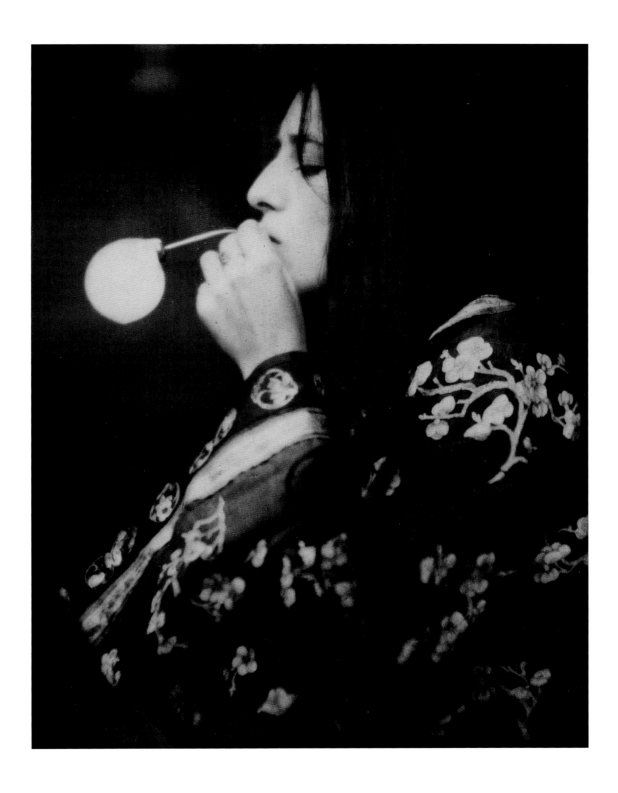

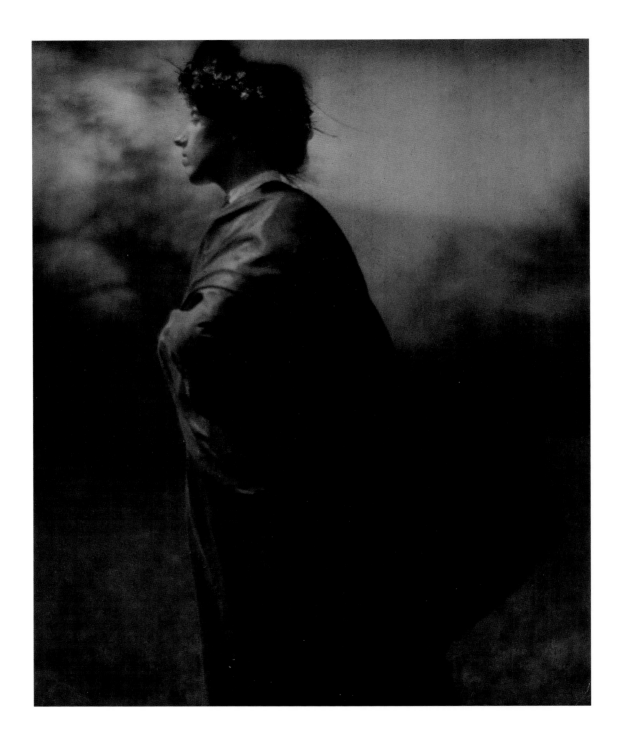

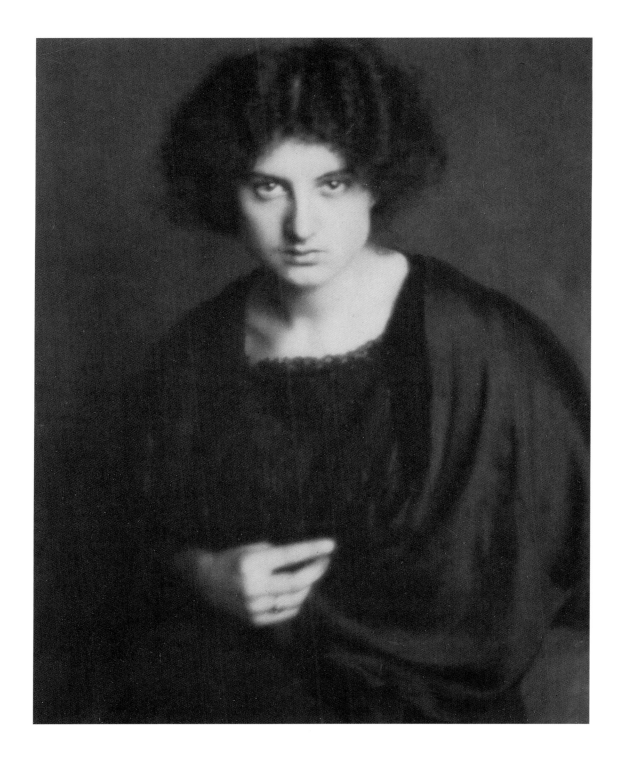

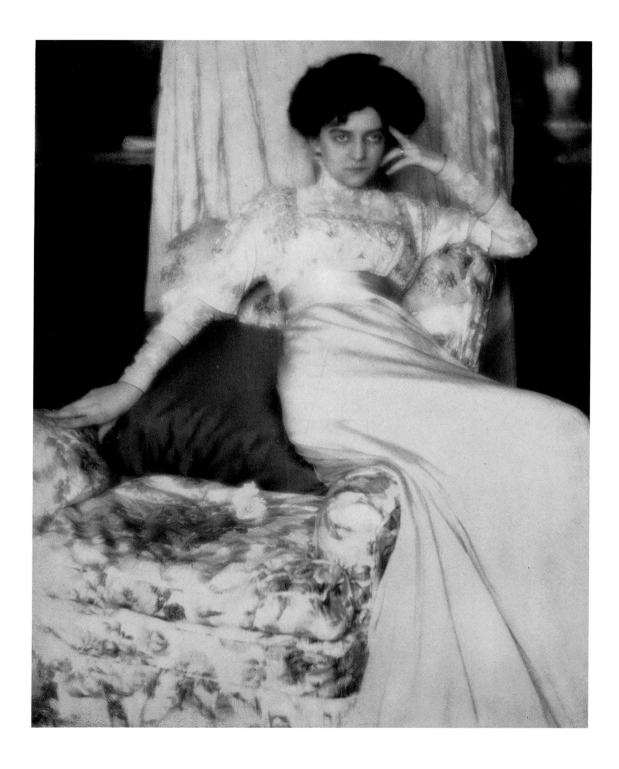

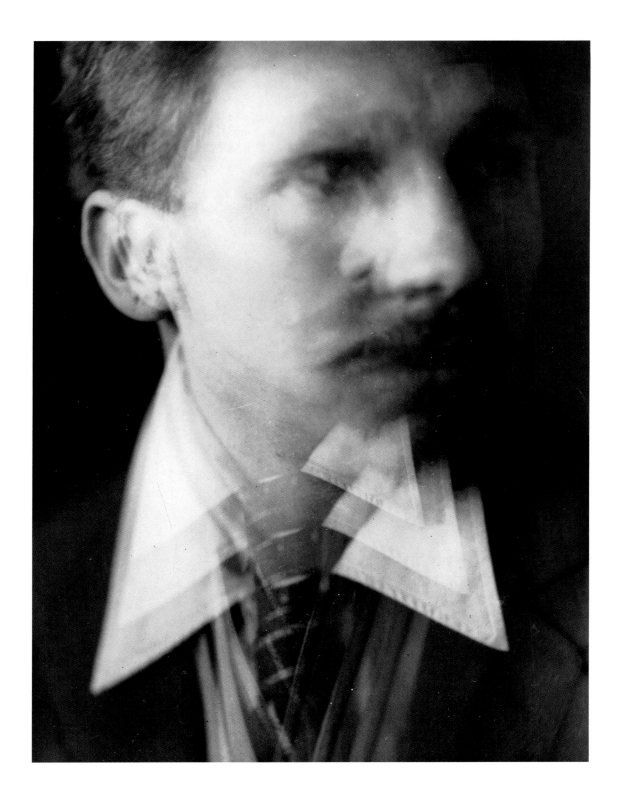

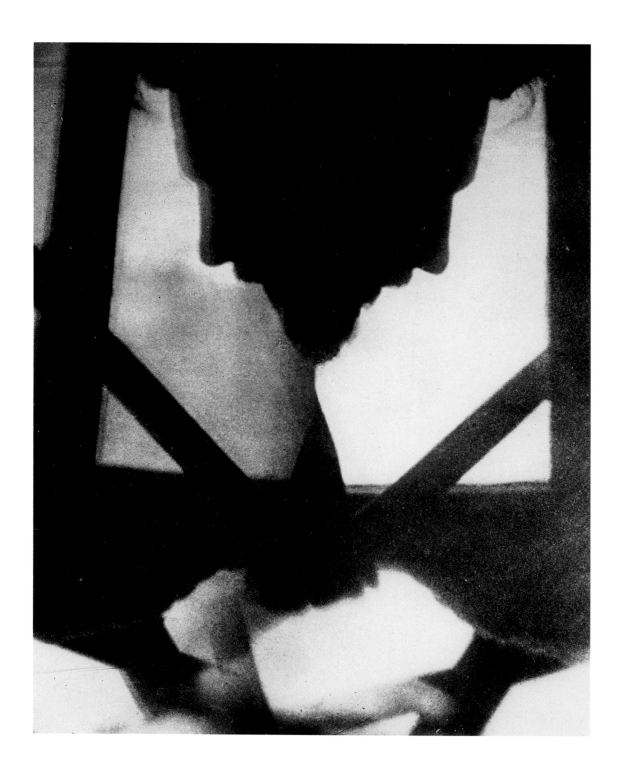

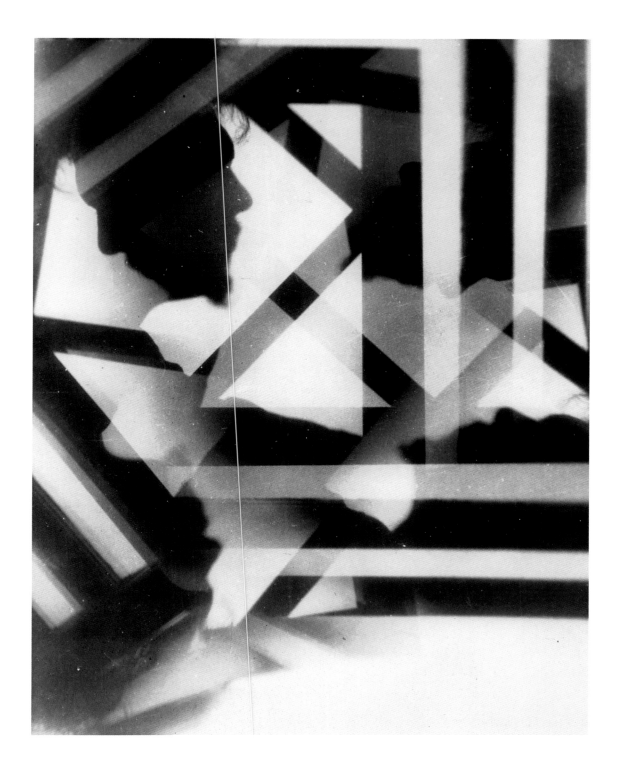

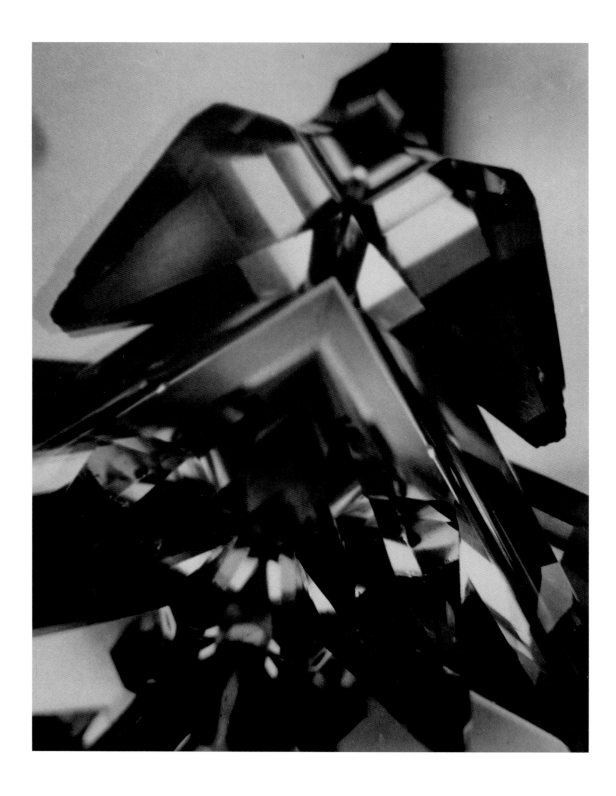

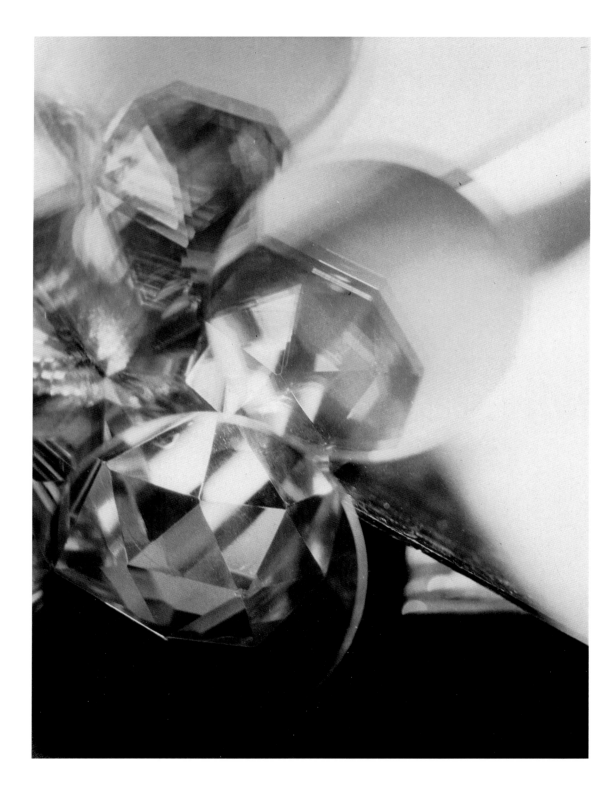

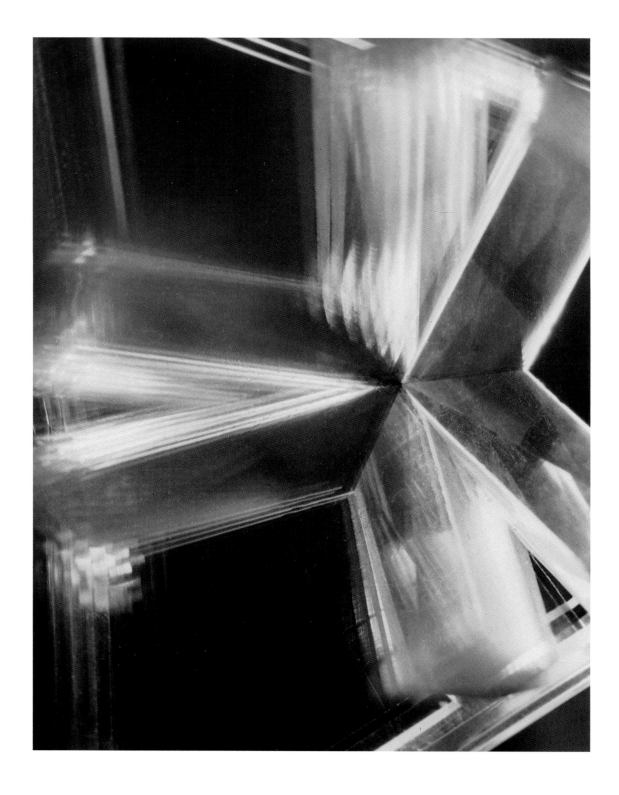

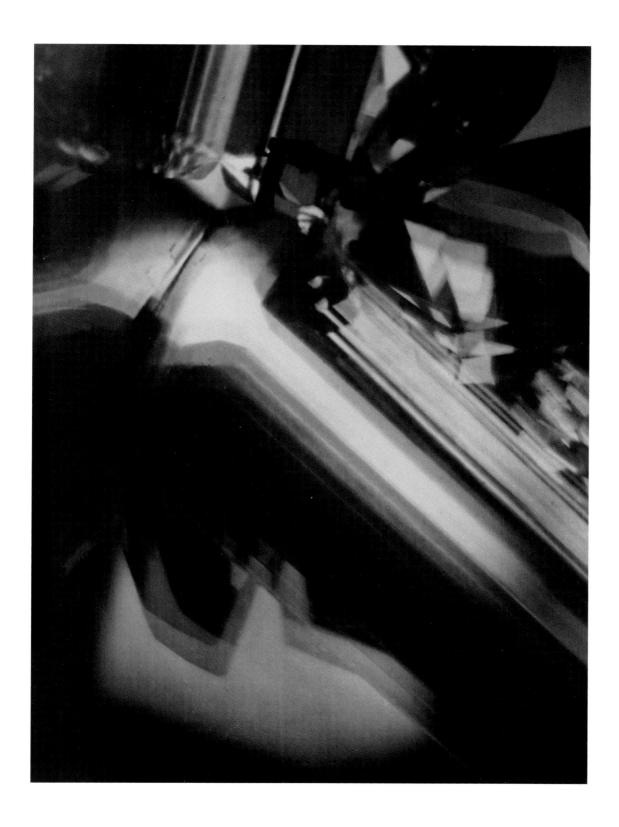

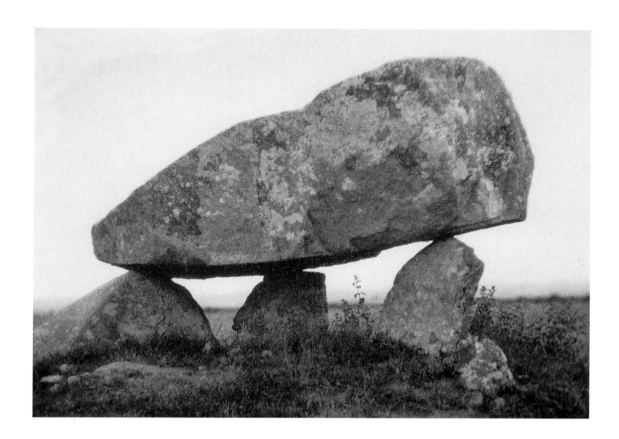

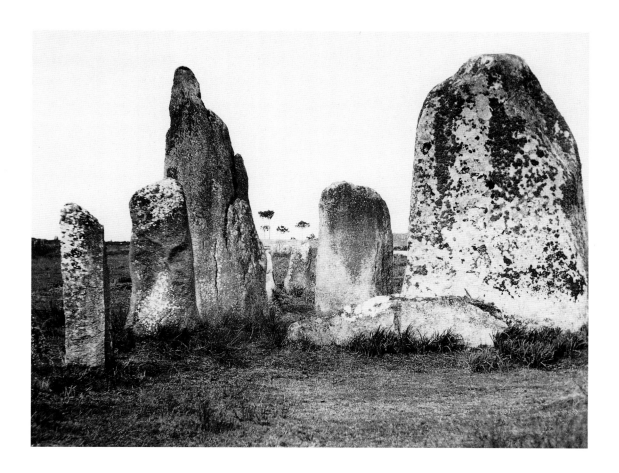

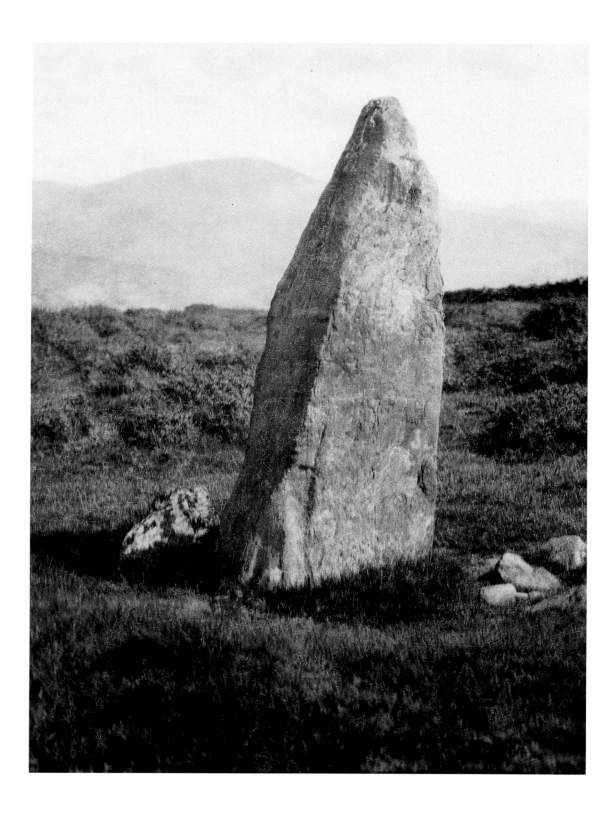

Alvin Langdon Coburn's Vorticist Experiments
Reinhold Mißelbeck

ALVIN LANGDON COBURN, like the German Heinrich Kuehn, might well be regarded simply as a conservative photographer working in a traditional way, had it not been for an episode in his life which makes his position unique. With his landscapes and cityscapes, published in books such as *London* (1909), *New York* (1910) or *Moor Park* (1915), but especially with his portrait work, which he presented to the public in *Men of Mark* (1913) and *More Men of Mark* (1922), he revealed himself as a photographer who, well into the twenties, clung to the tradition of Pictorialist printing techniques, to photogravure, and thus to the modes of expression of Pictorialism. While he had harmoniously adapted his style to Alfred Stieglitz's *Camera Work* of the first decade, the radical changes in photography which were introduced in the USA by Alfred Stieglitz's picture "Stearage" (1907) with regard to the subject, and by Straight Photography and Group F 64 around Ansel Adams and Edward Weston with regard to style and concept, completely passed him by. "Steichen faced the end of Pictorialist photography by studying art forms in nature and new ideas about proportion. This intelligent decision helped develop the metaphoric tradition that would sustain two generations of American photographers from Edward Weston to Paul Caponigro. It represented a firm commit-

ment to realism in photography. But the idealist tendency in Coburn's personality was too strong to allow him to make the transition from Pictorialism to Straight Photography."[1]

Nevertheless, for half a decade, Alvin Langdon Coburn pursued a very special path. When he went to England in 1912, he soon established contact with the writer Ezra Pound, who was then at the center of the artistic avant-garde. Futurism, with its revolutionary slogans in particular, did not fall on deaf ears in England, and its spiritual leader, F. T. Marinetti, had been invited to London as early as 1910 in order to introduce his ideas to a wider audience. In London, the economic crisis, strikes and the unions, as well as the increasingly vociferous tone of the Suffragettes, prepared the economic and social background for a growing readiness on the part of artists and intellectuals to break with tradition and to react positively to the aggressive tone of the Futurists. In 1913, the artists Frederick Etchells, Cuthbert Hamilton, Wyndham Lewis and Edward Wadsworth had jointly founded the Group of English Cubists, for whom the magazine *Blast* was both forum and mouthpiece; the keyword came from the pen of the writer May Sinclair, with her family chronicle *The Tree of Heaven*, in which she described the progressive artists as being at the center of the whirlpool, as acting in the "Vortex." William C. Wees describes this in his book *Vorticism and the English Avant-Garde*: "From that Dantesque metaphor of the liberated sex life, the Vortex expands to include 'the Vortex of the fighting Suffrage woman' and 'the Vortex of revolutionary art.' In May Sinclair's view, everything seemed caught up in 'the immense Vortex of the young century.' The reason for that was, simply, 'If you had youth and life in you, you were in revolt.'"[2] But once Ezra Pound had associated the art of the English Cubists—and in particular that of Wyndham Lewis—with the idea of the "Vortex," the very first edition of *Blast* appeared on June 20th, 1914 as *Review of the English Vorticists*.[3]

After Alvin Langdon Coburn had executed several portraits of Ezra Pound, there followed sessions with the remaining Vorticists, and it gradually dawned on Coburn that photography should also be able to create images along the lines of Cubism. The decisive point came with his exhibition *Camera Pictures* in the Goupil Gallery in 1913 where, in addition to portraits, he also presented some of his New York photographs. In particular, his picture "The Thousand Windows" (1912), prompted his remark that it was "almost as phantastic in its perspective as a Cubist phantasy."[4] And indeed, this picture represents ways of seeing which we know from photographic Constructivism, with bird's-eye views and without any attempt to correct tilting lines by resorting to technical means. The camera takes photographs in the way the eye looks, and the photographer accepts optical distortions. But the picture "Roofs, Paris" (1913) is no less Cubist; here, roofs and chimneys fit together into a dense and opaque pattern of verticals and horizontals. Even the translation of a landscape motif—as in "From Mount Wilson" (1911)—already betrays the photographer's interest in a clear geometric structuring of his pictures. The picture is dominated by horizontals and verticals which criss-cross in the upper right-hand third, made up of the tree trunk and the connecting lines of the mountain chain and the branches; these in turn are bisected diagonally by the line of a mountain ridge, which finally combines with the slanting branches in the bottom right-hand. A Pictorial form which is at once brilliant and simple but is less severe in many of its details, and could serve as a textbook example of Cubist Pictorial composition. When we examine the graphic structure of the magazine *Blast*, it is striking how much importance the Vorticists attach to the work with horizontals and verticals.[5] It seems to me that these early photographic examples are of special significance since they demonstrate how strongly the principle of this avant-garde pictorial composition was already present in Alvin Langdon Coburn before the spark of Vorticism prompted him to experiment

with mirrors. The fact that a few months after Coburn's exhibition, his New York subjects were taken up by Lewis corroborates the idea that Coburn's art was deeply rooted in the Vorticist circle. A comparison of the two versions of "Liverpool Cathedral under Construction" (1919) with pictures such as "Study for Twostep" (1915) by William Roberts or "Enclosure" (1915) by Edward Wadsworth, also reveals the closeness of the links between the works of the Vorticists and Coburn's photographs.

Under the influence of the Cubist perspective, Alvin Langdon Coburn began to develop techniques to make use of photography along the ideas of these avant-garde artists. "Why should not its subtle rapidity be utilized to study movement? Why not repeated successive exposures of an object in motion on the same plate? Why should not perspective be studied from angles hitherto neglected or unobserved? Why, I ask you earnestly, need we go on making commonplace little exposures of subjects that may be sorted into groups of landscapes, portraits, and figure studies? Think of the joy of doing something which it would be impossible to classify, or to tell which was the top and which the bottom!"[6] Alvin Langdon Coburn put these ideas into practice, working with mirrors and prisms in order to divide up space in a Cubist manner. Among his most famous pictures of this type is a series of portraits of Ezra Pound, 1917, whose silhouette profile is framed by a pattern of horizontal, vertical and diagonal beams. It is interesting to compare this picture with Edward Wadsworth's "Newcastle" (1913), where we find a very similar pattern of light and dark, of movement and rhythm.

In spite of Coburn's revolutionary innovations, he was denied recognition by Ezra Pound of all people, who described Vorticist photography as second to its painting "in that it is an art of the eye, not of the eye and hand together."[7] It is this which prompted Alvin Langdon Coburn to break with the Vorticists and to go back to his

traditional photography. Nonetheless, his sense of struc-
tures, of a Pictorial framework which does not really need
a subject, remains an integral part of his art; it is not only
the oft cited "Liverpool Cathedral under Construction,"
which demonstrates how much he was still concerned with
the constructive, with contrast, and with light and dark in
later years. There are other, later pictures, such as
"Tree Interior" (1957), "Fishing Nets, Madeira" (1953),
or "Reflections" (1962), which reveal a lasting, deep-seated
interest in structures of Pictorial composition for which the
subject of the picture is no more than a trigger.

[1] Mike Weaver, *Alvin Langdon Coburn*,
 Symbolist Photographer 1882–1966. Beyond the Craft.
 New York: Aperture, 1986, p. 64.
[2] William C. Wees, *Vorticism and the English Avant-Garde*.
 Toronto/Buffalo 1972, p. 13.
[3] Ibid., p. 159 ff.
[4] Alvin Langdon Coburn, quoted from: Richard Cork,
 Vorticism and Abstract Art in the First Machine Age.
 London: G. Fraser, 1976, p. 495.
[5] William C. Wees studied the graphic design of *Blast* and
 came to the conclusion that "Anything that seemed clear-
 cut, hard, rigid, and uncompromising gained the Vorticists'
 approval." Cf. William C. Wees, 1972 (note 2), p. 172 ff.,
 quoted from: p. 178.
[6] Alvin Langdon Coburn, quoted from: Richard Cork, 1976
 (note 4), p. 499.
[7] Ezra Pound, quoted from: Nancy Newhall,
 Alvin Langdon Coburn: A Portfolio of Sixteen Photographs.
 Rochester/New York: George Eastman House, 1962, p. 14.

Alvin Langdon Coburn Collection at George Eastman House
Marianne Fulton

ALVIN LANGDON COBURN, born in Boston in 1882, began taking pictures at the age of eight. By the time he was a teenager, he was clearly and consciously an artist. With just the right necktie and rings on every finger, he clearly identified with the mood of the 1900s. Later in life he forsook the rings and concentrated on masterful photographic precision. The early years of his professional life were devoted to experimenting with processes such as gum platinum and photogravure. It is this work for which he is best known. After their marriage, he and his wife Edith elected to live in Wales.

In the course of the correspondence between the Coburns in Wales and the Newhalls, Nancy and Beaumont, director of George Eastman House in Rochester, New York, the arrangements were set up for Coburn's subsequent gift. The majority of the Alvin Langdon Coburn collection was bequeathed to the Eastman House in the photographer's will. Prior to his death, on November 23, 1966, in North Wales, Coburn had arranged with Kodak Limited for the enormous number of prints and other items to be taken to their collection in Harrow. Six months after Harrow received the work, his friend Beaumont Newhall received an update from Harrow announcing that the Coburn collection (estimated at approximately "half-a-ton") was being prepared for shipment to the Rochester museum.

After cataloguing, the image and negative count came to 19,217. This number does not include a large selection of letters, manuscripts, scrapbooks, and other personal belongings, including a bronze bust of Coburn as a young man. The image and process categories included: photogravures that Coburn produced for many different books, such as *London* (1909), H. G. Wells's *The Door in the Wall and Other Stories* (1911), and the periodical *Camera Work*; platinum, gum platinum, and gum bichromate prints of the Grand Canyon, Yosemite, California, and Europe; portraits in his extended series "Men of Mark" as well as some of Gertrude Stein, and a large variety of other subject matter. This important body of work came to George Eastman House partly through early gifts and purchases, as well as through Coburn's bequest. Perhaps the most significant factors in this sizeable donation were the three personalities involved: Alvin Langdon Coburn and Nancy and Beaumont Newhall shared a mutual trust, love and respect.

Recalling their 1952 trip to meet Coburn in Wales, Nancy Newhall gives a brief insight into Coburn's well-known exuberance, multifaceted interests, eccentricities, and links to mystical religions by recounting a conversation with J. Dudley Johnson of the Royal Photographic Society: "Alvin has been having a wonderful time," he said. "Whenever I go to see him, we go see a play he has written or maybe hear him preach." "What!" "Oh yes," said Johnson, twinkling; "I think you'll enjoy meeting Alvin."

The correspondence between the three, which is included in the manuscript collection, begins before the Newhalls came to the newly constituted George Eastman House in 1948. The pace quickens in 1952 when Newhall—still addressing his greeting to "Mr. Coburn"—cautiously requests to have prints on loan "if this would meet with your approval and that of the Royal Photographic Society." (August 8, 1952). To give an idea of how the correspondence reflects a growing friendship while displaying a constant concern for the images and their care, short excerpts are included here from letters written in the years before the photographer's death:

August 13, 1952
Coburn asks Beaumont Newhall to come to "Awen," the adopted home of his wife and himself in North Wales. "... I would appreciate your advice about the placing of some of them photographs in America on my death."

August 18, 1952
Newhall expresses his continued interest in a show of "original photogravures," because the process "is a direct printing medium and such a show would be unique and of great interest. It is most kind of you to offer to let us add these to our permanent collection."

November 24, 1952
Newhall asks to buy a selection of platinum print right away.

December 30, 1952
Coburn sends 28 prints, including "Station Roofs, Pittsburgh" (1910) and "The Great Temple, Grand Canyon" (1911).

July 17, 1953
Coburn writes that "most of my things exist only as a single unique copy!" He goes on to explain that in the earlier exhibits the large platinum and gum bichromate prints were $100 each, but if the museum will take eleven, he will make the price a total of $1000.

September 30, 1953
Newhall writes that the "photographs have arrived in perfect condition, and we are delighted to have them." Now, he says, the Eastman House has "a good nucleus for a Coburn collection."

August 17, 1955
Coburn's concern for his life's work is a situation that photographers still must struggle with today: "I am also wondering what to do with all my negatives. I am 73 years of age and will not live for ever, and I do not quite know whether to have them destroyed at my death or not? Have you any suggestions?"

September 8, 1961
In answer to letters from the Newhalls, Coburn exclaims in his exuberant style that "a 'big show' at Eastman House, sounds good to me" He continues, "Fritz Greuber [sic] also wants me to have a show in Germany [photokina] so I am keeping very much alive!"

October 20, 1961
Nancy Newhall responds in kind: "Here's to the BIG SHOW! It will be, to this generation, a relevation!"

April 1, 1962
Writing to the Newhalls, Coburn states, "I think you should really have my collection, and also several large scrap books of press-cuttings, which are of historical interest!"

Coburn now occasionally writes short notes about his travel plans and the whereabouts of prints that are on loan, "In case I should suddenly die!" A year before his death, he sent the Newhalls a list of places where prints were stored in his house. It must have been somewhat crowded at "Awen"—here is an excerpt from his list (emphasis and spelling are Coburn's):

"*In my bedroom over clothing:* Scrap books, Books, Files of letters. *In a small bedroom:* Portfolios under shawl, marked George Eastman House museum. *In my Study under shawl: Many folios containing my best prints. In*

Drawing Room (under Encyclopaedia Britannica): Copies of my own published books ..."

January 28, 1964

Beaumont Newhall, travelling without Nancy this time, fails to meet Coburn in Great Britain. Commenting on the situation, the aging and sick Coburn writes, "Yes your visit here belongs to things which are 'outside time.' It seems to make deeper and richer our already strong friendship which I believe will continue into 'The Great Beyond' where things do not change."

Just as Beaumont Newhall promised Coburn, in a 1962 letter regarding the bequest, today's staff at George Eastman House continues to "house and preserve and maintain your collection with the respect and care and love which, making this decision, you expect from us."

Chronology

1882	Born on June 11 in Boston.
1889	Father dies.
1890	Receives a 4 x 5 inch Kodak Camera.
1897	Photos by Coburn are exhibited in Boston.
1898	Meets the photographer Fred Holland Day, a distant cousin.
1899	Travels to London together with mother and Fred Holland Day. Meets Frederick H. Evans.
1900	The Royal Photographic Society exhibits nine Coburn photos together with photographs by Fred Holland Day and Edward Steichen.
1902	Returns to America. Opens studio at 384 Fifth Avenue in New York.
1903	Solo exhibition at Camera Club of New York. Works with Gertrude Käsebier. Elected member of Photo-Secession and the Linked Ring.
1904	Starts series of portraits with George Bernard Shaw.
1906	Starts working on photographs for frontispieces of the 24 volume *Collected Works* of Henry James. Has solo exhibition at the Royal Photographic Society with foreword in catalogue by George Bernard Shaw. Begins to study photogravure printing at London County Council School of Photoengraving. Coburn photos published widely in England and the United States.
1907	Various exhibitions in New York, one of them at the Photo-Secession Gallery. Takes autochromes for special supplement for the art magazine *The Studio*.
1908	Travels to Dublin to photograph William Butler Yeats and others.
1909	*London*, published with an introduction by Hilaire Belloc. Moves to Hammersmith into a house he calls "Thameside." Sets up two printing presses to make photogravures. Solo exhibition at Photo-Secession Gallery in New York.
1910	Publishes *New York* with an introduction by H. G. Wells. Takes photos of industrial subjects in Pittsburgh.
1911	Visits Yosemite and the Grand Canyon.
1912	Photographs New York from its pinnacles. Marries Edith Clement from Boston. Moves to Great Britain, where he remains.
1913	Solo exhibition at Goupil Gallery in London including the series "New York from its Pinnacles." *Men of Mark* published with 31 portraits.
1917	Makes Vortographs, exhibits Vortographs together with his paintings at Camera Club of London.
1922	Publishes *More Men of Mark*. Gives lecture at the Royal Photographic Society on *Astrological Portraits*.

1924	Second solo exhibition at the Royal Photographic Society.
	At the opening Coburn gives talk about *Photography and the Quest for Beauty*.
1930	Gives up his house in Hammersmith. Moves to the north of Wales for the rest of his life.
	Gives part of his photographic collection to the Royal Photographic Society.
1931	The Royal Photographic Society elects him an honorary member.
1932	Coburn becomes a naturalized British subject.
1952	Beaumont and Nancy Newhall visit Coburn in Wales.
1954	First of three successive winter visits to Madeira, Portugal.
	Coburn starts to take a great number of photos again.
	23 Coburn photos of Edinburgh are published in a new edition
	of Robert Louis Stevenson's *Edinburgh: Picturesque Notes*.
1957	Third solo exhibition at the Royal Photographic Society. His wife Edith dies.
1962	Retrospective exhibition at the University of Reading.
	George Eastman House publishes *Alvin Langdon Coburn: A Portfolio of Sixteen Photographs*
	with an introduction by Nancy Newhall.
1966	Alvin Langdon Coburn's autobiography is published, edited by Helmut and Alison Gernsheim.
	Coburn dies on November 23 in his home in Wales.

This chronology does not contain Coburn's study of religion and his life as a Freemason,
which after World War One absorbed him more and more.

Bibliography

The following bibliography was compiled by Rachel Stuhlman and drawn primarily from the resources of the International Museum of Photography at George Eastman House, with additional contributions by Mike Weaver. Entries are chronological. In addition to the works cited below, a list of magazines which reproduced Coburn photographs between 1900 and 1912 has been compiled, and is available in the Library of the International Museum of Photography at George Eastman House.

Books by Alvin Langdon Coburn

London. With an introduction by Hilaire Belloc. London: Duckworth & Co.; New York: Brentano's, 1909. Illustrated with 20 photogravures.

The Euxit Camera: An Appreciation. London: J. F. Shew & Co., [1909?]. Illustr. with one photogravure and 3 halftones.

New York. Foreword by H. G. Wells. London: Duckworth & Co.; New York: Brentano's, 1910. Illustrated with 20 photogravures.

Men of Mark. London: Duckworth & Co.; New York: Mitchell Kennerley, 1913. Illustrated with 33 photogravures.

Moor Park, Rickmansworth: A Series of Photographs. With an introduction by Lady Ebury. London: Elkin Mathews, 1915. Illustrated with 20 photogravures.

The Book of Harlech. Harlech: D. H. Parry, 1920. Illustrated with 20 photogravures.

More Men of Mark. London: Duckworth & Co.; New York: A. A. Knopf, 1922. Illustrated with 33 collotypes.

Photography and the Quest of Beauty. London: Harrison & Sons, 1924. Reprinted from the *Photographic Journal*, April 1924.

Fairy Gold: A Play for Children and Grown-ups Who Have Not Grown Up. Music by Sir Granville Bantock. London: W. Paxton & Co.; Boston: Birchard and Co., 1938.

Alvin Langdon Coburn, Photographer; An Autobiography. Edited by Helmut and Alison Gernsheim. London: Faber; New York: F. A. Praeger, 1966. Reprinted with a new introduction by Helmut Gernsheim. New York: Dover Publications, 1978.

Books Illustrated by Alvin Langdon Coburn

Fox, Minnie C. (ed.), *The Blue Grass Cook Book*. New York: Fox, Duffield & Company, 1904. Illustrated with 13 halftones.

Howells, William Dean. *London Films*. London and New York: Harper Brothers Publishers, 1906. Illustrated with 24 plates, including 16 halftones of photographs, one credited to Coburn.

Bayley, R. Child. *The Complete Photographer*. London: Methuen & Co.; New York: Doubleday, 1906. Illustrations include one halftone of Coburn photograph.

Maeterlinck, Maurice. *The Intelligence of the Flowers*. Translated by Alexander Teixeira de Mattos. New York: Dodd Mead and Company, 1907. Illustrated with 4 photogravures.

Guest, Anthony. *Art and the Camera*. London: George Bell & Sons; New York: Macmillan, 1907. Illustrations include one halftone of Coburn photograph.

Jackson, Holbrook. *Bernard Shaw*. London: Grant Richards; Philadelphia: G. W. Jacobs, 1907. Illustrated with one halftone.

James, Henry. *The Novels and Tales of Henry James*. New York: Charles Scribners & Sons, 1907–1909, 1917. London: Macmillan & Co., 1909–1913. Illustrated with 24 photogravure frontispieces. Besides the trade edition, a large paper edition of 156 copies was issued by Scribners.

Nevill, Ralph and Jerringham, Charles Edward. *Piccadilly to Pall Mall: Manners, Morals and Man*. London: Duckworth & Co., 1908. Illustrated with 2 photogravures.

Holme, Charles (ed.). *Colour Photography and Other Recent Developments of The Art of the Camera*. London, Paris & New York: *The Studio*, 1908. Special issue of *The Studio*. Illustrations include 6 halftones from Coburn photographs, 3 in color.

Meredith, George. *The Works of George Meredith*. Memorial edition. London: Constable & Co., 1909–1911; New York: Charles Scribners & Sons, 1909–1912. Illustrated with one photogravure.

Hartmann, Sadakichi. *Landscape and Figure Composition*. New York: Baker & Taylor, 1910. Illustrations include 2 halftones of Coburn photographs.

Anderson, A. J. *The Artistic Side of Photography in Theory and Practice*. London: Stanley Paul & Co., 1910; New York: Dodd, Mead & Co., 1911. Illustrations include 4 Coburn photogravures.

Henderson, Archibald. *Mark Twain*. New York: F. A. Stokes Company, 1910; London: Duckworth & Co., 1911. Illustrated with 10 halftones, 2 from autochromes.

Wells, H. G. *The Door In The Wall and Other Stories*. New York & London: Mitchell Kennedy, 1911; London: Grant Richards Ltd., [1915]. Illustrated with 10 photogravures. Limited to 600 copies. Sixty numbered copies, signed by Wells and Coburn and inscribed "1915," were issued under Grant Richards' imprint. "The 10 illustrations were printed in London, but in shipment a nail was driven through 300 of one subject, leaving only 300 complete sets from which that number of perfect books were manufactured. Subsequently the 300 remaining books, lacking one illustration, were bound in light brown boards, with the missing photogravure replaced by an aquatone." (Cary, Melbert B., Jr. *A Bibliography of the Village Press*. New York: Press of the Woolly Whale, 1938.) Reprinted with an afterword by Jeffrey A. Wolin. Boston: David R. Godine, 1980. With halftone illustrations. The Coburn bequest in the collection of the George Eastman House has 3 copies of a bound volume of 10 photogravure plates, lacking title page and text, with the covers stamped "The Door In the Wall By H. G. Wells and Alvin Langdon Coburn."

Henderson, Archibald. George Bernard Shaw: *His Life and Works, A Critical Biography*. London: Hurst and Blackett; Cincinnati: Stewart Kidd, 1911. Illustrated with 3 halftones of photographs by Coburn, one from an autochrome.

Schnitzler, Arthur. *Anatol: A Sequence of Dialogues*. Paraphrased for the English Stage by Granville Barker. New York: Mitchell Kennerly, 1911. Illustrated with one halftone.

Henderson, Archibald. *Interpreters of Life*. London: Duckworth & Co; New York: Mitchell Kennerly, 1911. Illustrated with one halftone.

Shelley, Percy Bysshe. *The Cloud*. Los Angeles: C. C. Parker, 1912. Illustrated with 6 platinum prints. Limited to 60 copies.

Finch, G. H. *Modern English Books of Power*. San Francisco: Paul Elder & Co., 1912. Illustrated with one reproduction published without permission.

Chesteron, G. K. *London*. London: Privately Printed for Alvin Langdon Coburn and Edmund D. Brooks & their Friends, 1914. Illustrated with 10 photogravures.

Symons, Arthur. *London: A Book of Aspects*. Minneapolis: Privately Printed by Edmund D. Brooks, 1914. Limited to 2 copies.
"On 22 September 1906, I photographed Arthur Symons, and there was a plan that we should collaborate in a little book to be entitled *London: A Book of Aspects*, but it never fully eventuated! The Symons text was privately printed by my friend, Edmund D. Brooks, of Minneapolis, the collector of rare and precious books and manuscripts, and he had two copies of the Symons text and my London illustrations magnificently bound together with a specially printed title page, one copy for himself, and the other for me! These also contain one illustration, made specially for the Symons book, which does not exist in any other form. It is a picture of a coster's barrow in Edgeware Road" (Alvin Langdon Coburn. "Photographic Adventures," *Op. cit.*) Coburn bequeathed his copy to the Reading University Library.

Wells, H. G. *The Country of the Blind*. New York: Privately Printed, Christmas 1915. Illustrated with one reproduction by Coburn.

Cotton Waste: A Study of a Great Lancashire Industry. Manchester: Charles W. Hobson for William C. Jones, Ltd., 1920. Illustrated with 14 photogravures.

Manchester Civic Week Official Handbook. Manchester: Civic Week Committee, 1926. Illustrated with 12 halftones.

A Study in Storage. Manchester: Lloyd's Packing Warehouse Ltd., [1920s]. Illustrated with 12 halftones.

McCrossman, Mary (ed.). *The Letters of W. Dixon Scott*. London: Herbert Joseph, 1932. Illustrated with one halftone.

Stevenson, Robert Louis. *Edinburgh: Picturesque Notes*. Preface by Janet Adam Smith. London: Rupert Hart-Davis, 1954. Illustrated with 23 halftones.

Hutchins, Patricia. *Ezra Pound's Kensington: An Exploration, 1885–1913*. London: Faber & Faber, 1965. Illustrated with 8 halftones.

Manchester & The Sea. Manchester: Cloister Press, n.d. Illustrated with 10 photogravures.

Articles by Alvin Langdon Coburn

"Ozotype: A Few Notes on a New Process." *Photo Era*, 5, no. 3, August 1900, pp. 33–35.

"American Photographs in London." *Photo Era*, 6, no. 1, January 1901, pp. 209–215.

"The California Missions: San Fernando Rey." *Photo Era*, 9, no. 2, August 1902, pp. 51–53.

"The California Missions: Santa Barbara." *Photo Era*, 9, no. 3, September 1902, pp. 116–118.

"More About Gum Prints." *Los Angeles Camera Club News*, September 1902, unpaged.

"A Few Hints for Platinotype Workers." *Camera Craft*, 5, no. 6, October 1902, pp. 235–238.

"The California Missions: San Gabriel." *Photo Era*, 9, no. 5, November 1902, pp. 204–206.

"The California Missions: San Juan Capistrano." *Photo Era*, 9, no. 6, December 1902, pp. 253–255.

"New Portraits of a Group of British Authors." *The Century Illustrated Monthly Magazine*, 70, n. s. 48, no. 1, May 1905, pp. 11–18. Illustrated with 7 halftones.

"My Best Picture and Why I Think So." With an introduction by F. J. Mortimer. *The Photographic News*, 51, no. 579, n. s., February 1, 1907, pp. 82–84.

"Graduated Colour Screens." *Photography*, 29, no. 1119, April 19, 1910, pp. 347–348. Reprinted in *Graduated Light Filters: A Simple Explanation of their Action and Use in Photography*. London: Sanger, Shepard & Co, n. d., pp. 10–11.

"Artists of the Lens: The International Exhibition of Pictorial Photography in Buffalo." *Harper's Weekly*, 54, no. 2814, November 26, 1910, p.11. Reprinted in *Camera Work*, no. 33, January 1911, pp. 63–65, and *Academy Notes*, 6, no. 1, January 1911, pp. 5–8.

"Coburn in California: A Characteristic Letter." *Photography*, 32, no. 1193, September 19, 1911, p. 239.

"The Relation of Time to Art." *Camera Work*, no. 36, October 1911, pp. 72–73. Repr. in Lyons, Nathan (ed.). *Photographers on Photography*. Englewood Cliffs: Prentice-Hall, in collaboration with the George Eastman House, 1966, pp. 52–53, and Green, Jonathan (ed.). *Camera Work: A Critical Anthology*. New York: Aperture, 1973, pp. 215–216.

"Alvin Langdon Coburn, Artist-Photographer—By Himself." *The Pall Mall Magazine*, 51, no. 242, June 1913, pp.

757–763. Reprinted in *Wilson's Photographic Magazine*, 51, no. 1, January 1914, pp. 18–24. Illustrated with 7 halftones.

"Photogravure." *Platinum Print*, 1, no. 1, October 1913, pp. 2–5, 15, and "Supplement." Illustrated with a photogravure.

"Men of Mark." *Forum*, 50, November 1913, pp. 653–669.

"Anatole France—An Artist-Photographer's Impressions." *The Bookman*, 45, no. 269, February 1914, pp. 258–259. Illustrated with one halftone.

"The Sea Pictures of John Masefield." *The Bookman*, 45, no. 270, March 1914, pp. 300–302. Illustrated with one halftone.

"Yone Noguchi." *The Bookman*, 46, no. 271, April 1914, pp. 33–36. Illustrated with one halftone.

"Eight Photographs from Foreign Lands." *The Century Illustrated Monthly Magazine*, 88, n. s. 66, no. 2, June 1914, pp. 233–240. Illustrated with 8 halftones.

"Modern Photography." *Colour*, 1, no. 4, November 1914, pp. 158–159.

"British Pictorial Photography." *Platinum Print*, 1, no. 7, February 1915, pp. 7–10. Illustrated with one halftone (cover) by Coburn.

"The Old Masters of Photography." *Century Illustrated Monthly Magazine*, 90, n. s. 68, no. 6, October 1915, pp. 908–920.

"Snapshots From Home For The Pictorial Photographer." *The Amateur Photographer & Photographic News*, 62, no. 1623, November 8, 1915, pp. 376–377.

"The Future of Pictorial Photography." *Photograms of the Year*, 1916, pp. 23–24. Reprinted in: Newhall, Beaumont (ed.). *On Photography: A Source Book of Photo History in Facsimile*. Watkins Glen: Century House, 1956, pp. 149–150, and Lyons, Nathan (ed.). *Photographers on Photography*. Englewood Cliffs: Prentice-Hall, in collaboration with the George Eastman House, 1966, pp. 53–55.

"Astrological Portraiture." *The Photographic Journal*, 63, n. s. 47, February, 1923, pp. 50–52. Text of an address delivered to the Royal Photographic Society's Pictorial Group, November 21, 1922.

"Photography and the Quest of Beauty." *The Photographic Journal*, 64, n. s. 48, April 1924, pp. 159–167. Text of an address delivered at the Royal Photographic Society, February 5, 1924, for the opening of an exhibition of Coburn's work.

"The Living Symbols of Freemasonry." *Transactions of the Manchester Association for Masonic Research*, 25, 1935, pp. 40–56.

"Mystical Death." *Transactions of the Merseyside Association for Masonic Research*, 16, 1938, pp. 45–57.

"Freemasonry in Times of Stress." *Transactions of the Manchester Association for Masonic Research*, 30, 1940, pp. 20–39.

"Pythagoras." *Transactions of the Merseyside Association for Masonic Research*, 19, April 1941, pp. 20–26.

"The Vital and Immortal Principle." *Transactions of the Manchester Association for Masonic Research*, 31, 1941, pp. 9–17.

"The Kabbalah." *Transactions of the Manchester Association for Masonic Research*, 35, 1945, pp. 28–50.

"Substituted Secrets." *Transactions of the Merseyside Association for Masonic Research*, 25, September 30, 1947, pp. 35–42.

"Bernard Shaw, Photographer." *Photoguide Magazine*, 1, no. 9, December 1950, pp. 10–17.

"George Bernard Shaw: 26 July 1856 to 2 November 1950." *The Photographic Journal*, 91, January 1951, p. 30.

"Cornelius Agrippa." *Transactions of the Merseyside Association for Masonic Research*, 29, April 17, 1951, pp. 7–15.

"Frederick H. Evans." *Image*, 2, no. 9, December 1953, pp. 58–59.

"Utopia and Freemasonry." *Transactions of the Manchester Association for Masonic Research*, 46, 1956, pp. 44–63.

"Retrospect." *The Photographic Journal*, 98, 1958, pp. 36–40. Text of address delivered at the Royal Photographic Society meeting, October 22, 1957, in conjunction with a retrospective exhibition.

"Photographic Adventures." *The Photographic Journal*, 102, no. 5, May 1962, pp. 150–158. Text of address delivered January 23, 1962 at the University of Reading, for the opening of a retrospective exhibition.

"The Question of Diffusion." *Semi-Achromatic Lenses Manufactured by Pinkham & Smith Company*. Boston: Pinkham & Smith, n. d. Illustrations include 2 halftones after Coburn photographs.

The Shrine of Wisdom, 1–28, 1919–1947. Anonymous editorial board. That Coburn was a contributor, and probably

an editor, is not in doubt, although the members of the Universal Order, in accordance with the doctrain of impersonality, declined to attribute individual contributions to Coburn.

Selected List of Articles Illustrated by Alvin Langdon Coburn

J. P. C. "A New Aspect of London: The City through an American Camera." *The Pall Mall Magazine*, 37, no. 156, April 1907, pp. 386–394. Illustrated with 7 halftones.

Masefield, John. "Liverpool, City of Ships." *The Pall Mall Magazine*, 39, n. s. 5, no. 167, March 1907, pp. 272–281. Illustrated with 9 halftones.

Henderson, Archibald. "Mark Twain." *Harper's Monthly Magazine*, 118, no. 708, May 1909, pp. 948–955. Illustrated with 4 halftones.

Collins, J. P. "The City of Mr. Chamberlain: Birmingham and its New University." *The Pall Mall Magazine*, 44, no. 195, July 1909, pp. 2–13. Illustrated with 7 halftones.

Henderson, Archibald. "Old Edinburgh." *Harper's Monthly Magazine*, 119, no. 713, October 1909, pp. 705–719. Illustrated with 8 halftones.

Henderson, Archibald. "In Praise of Bridges." *Harper's Monthly Magazine*, 121, no. 726, November 1910, pp. 925–933. Illustrated with 8 halftones.

Maeterlinck, Maurice. "Foretelling the Future: How Far May We Peer Into the Great Unknown?" *Nashes Magazine*, September 1914, pp. 721–733; April 1915, pp. 185–194. Illustrated with 7 halftones.

Masefield, John. "Ships." *Harper's Monthly Magazine*, 130, no. 775, December 1914, pp. 115–122. Illustrated with 7 halftones.

Broadcasts by Alvin Langdon Coburn

"Illustrating Henry James by Photography." British Broadcasting Corporation. Third Programme. July 17 & July 24, 1953.

"Two Visits to Mark Twain." B. B. C. Third Programme. November 21, 1954 & January 1, 1955. Text published in *The Listener*, 52, no. 1344, December 2, 1954, p. 947.

"Photographing George Meredith." B. B. C. Home Service. April 22, 1958. Text published in *The Listener*, 59, no. 1518, May 1, 1958, pp. 731–732. Reprinted in Lai, T. S. (ed.). *Essays for You*. Hong Kong: University Book Store, n. d.

"Musicians in Focus." B. B. C. Home Service. July 17, 1960.

"A World of Sound: Was Confucius Right?" B. B. C. Home Service, January 16, 1964.

"Coburn the Photographer." B. B. C. Tonight television. January 29, 1964.

Exhibition Catalogues and Checklists: Solo Exhibitions and Exhibitions Arranged by Alvin Langdon Coburn

Catalogue of an Exhibition of Photographs by Alvin Langdon Coburn Held at His Studio, Number 827 Boylston Street Boston. Boston: 1903.

Catalogue of an Exhibition of Photographs: The Work of Alvin Langdon Coburn of Boston, Fellow of the Photo-Secession. Philadelphia: Philadelphia Photographic Society, 1903.

Catalogue of an Exhibition of the Work of Alvin Langdon Coburn. Preface by George Bernard Shaw. London: Royal Photographic Society; Liverpool: The Liverpool Amateur Photographic Association, 1906. Shaw's essay reprinted in *Photography*, 21, no. 900, February 6, 1906, pp. 115–117; *Wilson's Photographic Magazine*, 43, no. 591, March 1906, pp. 107–109; *Photo-Era*, 16, no. 3, March 1906, pp. 173–176; *Camera Work*, 15, July 1906, pp. 33–35; *Contemporary Photographer*, 2, no. 1, Summer 1961, pp. [17–20].

Catalogue of an Exhibition of the Work of Alvin Langdon Coburn, At the City Art Gallery, Leeds. Leeds: The Leeds Photographic Society, 1906.

Photo-Secession Galleries: Exhibition of Photographs by Alvin Langdon Coburn, March Eleventh to April Tenth, MDCCCCVII. New York: Photo-Secession Galleries, 1907.

Photographs by Alvin Langdon Coburn. New York: Montross Gallery, 1910.

An Exhibition of Photographs by Alvin Langdon Coburn. Los Angeles: The Friday Morning Club, 1911.

An Exhibition Illustrating the Progress of the Art of Photography in America, at the Montross Art Galleries, New York, October Tenth to Thirty-First, MCMXII. Foreword by Temple Scott. New York: Village Press, 1912. Exhibition organized by Coburn.

An Exhibition of Photographs by Alvin Langdon Coburn. Los Angeles: Blanchard Art Gallery, 1912.

Camera Pictures by Alvin Langdon Coburn. Statements by W. Howe Downes and Coburn. London: Goupil Gallery, 1913.

Buffalo Fine Arts Academy. Albright Art Gallery. *Catalogue of an Exhibition of The Old Masters of Photography Arranged by Alvin Langdon Coburn.* Buffalo: Buffalo Fine Arts Association, 1915. Contains a preface by Coburn.

Vortographs and Paintings by Alvin Langdon Coburn. Unsigned essay by Ezra Pound and postscript by Coburn. London: Camera Club, 1917. A revision of Pound's essay was published in Pound, Ezra. *Pavannes and Divisions.* New York: A. A. Knopf, 1918.

Alvin Langdon Coburn, 1882–1966: An Exhibition of Photographs from the International Museum of Photography at George Eastman House, Rochester, New York. Text by Paul Blatchford. London: Arts Council of Great Britain, 1978.

Alvin Langdon Coburn, 1882–1966, Man of Mark: Centenary. Introduction by Margaret Harker. Essay by Mike Weaver. Bath: The Royal Photographic Society, 1982.

Books on Alvin Langdon Coburn

Alvin Langdon Coburn: A Portfolio of Sixteen Photographs. Introduction by Nancy Newhall. Rochester: George Eastman House, 1962. George Eastman House Monograph no. 3.

Bogardus, Ralph Franklin. *Pictures and Texts: The Collaboration Between Henry James and Alvin Langdon Coburn.* Ann Arbor: Xerox University Microfilms, 1974. Ph. D. dissertation, University of New Mexico, 1974.

Blatchford, P. *Alvin Langdon Coburn, 1882–1966*. London: Camden Arts Centre, 1978.

Alvin Langdon Coburn, Man of Mark 1882–1966: Centenary. Essay by Mike Weaver. Brighton: The Royal Photographic Society, 1982.

Bogardus, Ralph F. Pictures and Texts: Henry James, Alvin Langdon Coburn, and New Ways of Seeing in Literary Culture. Ann Arbor: UMI Research Press, 1984. Studies in Photography no. 2.

Weaver, Mike. *Alvin Langdon Coburn, Symbolist Photographer, 1882–1966: Beyond the Craft*. New York: Aperture, 1986. (An Aperture Monograph, originally published as *Aperture* no. 104, 1986.)

Quest for Beauty: Alvin Langdon Coburn: Artist-Photographer, Wales 1919–1966. Mold: Clwyd County Council Library and Information Service, 1994.

Alvin Langdon Coburn and H. G. Wells: The Photographer and the Novelist: A Unique Collection of Photographs and Letters from the University Library's H. G. Wells Collection. Urbana: University Library; Kannert Art Museum, University of Illinois at Urbana-Champaign, 1997.

Articles on Alvin Langdon Coburn

Cummings, Thomas Harrison. "Some Photographs by Alvin Langdon Coburn." *Photo Era*, 10, no. 3, March 1903, pp. 87–92.

Allan, Sidney [Sadakichi Hartmann]. "A New Departure in Photography." *The Lamp*, 28, no. 1, February 1904

Allan, Sidney [Sadakichi Hartmann]. "The Exhibition of the Photo-Secession." *The Photographic Times* Bulletin, 36, no. 3, March 1904, pp. 97–105. Coburn discussed on pp. 100–101.

"Alvin Langdon Coburn." *Camera Work*, 6, April 1904, pp. [3–16]. Illustrated with 6 photogravures. Caffin, Charles H. "Some Prints by Alvin Langdon Coburn." *Ibid*., pp. 17–19. In addition to the portfolios issued in no. 6, April 1904, no. 15, July 1906, and no. 21, January 1908, single photogravures of Coburn photographs appeared in *Camera Work*, no. 3, July 1903, and no. 8, October 1904. A photogravure of Clarence H. White's portrait of Coburn and his mother is included in no. 32, October 1910.

Rice, H. L. "The Work of Alvin Langdon Coburn." *The Photographer*, 1, no. 9, June 25, 1904, pp. 132–133.

"Alvin Langdon Coburn." *The British Journal of Photography*, 53, no. 2387, February 2, 1906, pp. 85–86.

"Exhibitions: Alvin Langdon Coburn at the R. P. S." *The British Journal of Photography*, 53, no. 2388, February 9, 1906, p. 113.

"Alvin Langdon Coburn's Exhibition at 66 Russell Square." *The Photographic News*, 50, February 9, 1906, pp. 109–110.

"The Work of Alvin Langdon Coburn." *Photography*, 21, no. 901, February 13, 1906, pp. 134–136.

Hinton, A. Horsley. "One-Man-Show at the R. P. S.: Exhibition of Mr. Alvin Langdon Coburn's Photographs at the Royal Photographic Society." *The Amateur Photographer*, 43, no. 1115, February 13, 1906, pp. 135–136.

"A Further Note on Alvin Langdon Coburn's One-Man Show at the R. P. S." *The Photographic News*, 50, February 16, 1906, p. 129.

Bayley, F. Child. "Face to Face." *Photography*, 21, no. 902, February 20, 1906, p. 141.

J. P. C. "A New Aspect of London: The City Through an American Camera." *The Pall Mall Magazine*, 37, no. 156, April 1906, pp. 386–394. Illustrated with 7 halftones.

"The Function of the Camera." *The Liverpool Courier*, May 16, 1906. Reprinted in *The Amateur Photographer*, 43, no. 1130, May 29, 1906, pp. 447–448.

"Alvin Langdon Coburn." *Camera Work*, 15, July 1906, pp. [13–15]. Illustrated with 6 photogravures. Shaw, George Bernard. "Bernard Shaw's Appreciation of Coburn." *Ibid.* pp. 33–35. Reprint of preface from R. P. S. 1906 exhibition catalogue.

Thompson, Herbert. "Mr. Coburn's Work at Leeds." *The Amateur Photographer*, 44, no. 1160, December 25, 1906, pp. 571–572.

Hoppé, E. O. "Alvin Langdon Coburn." *Photographische Rundschau*, 20, Heft 15, 1906, pp. 175–176, and 17 unnumbered pages of reproductions.

Abel, Juan C. "Editorial Comment—Alvin Langdon Coburn." *The Photographer*, 6, no. 151, March 19, 1907, p. 323.

Allan, Sidney [Sadakichi Hartmann]. "Alvin Langdon Coburn—Secession Portraiture." *Wilson's Photographic Magazine*, 44, June 1907, pp. 251–252. Reprinted in Hartmann, Sadakichi. *The Valiant Knights of Daguerre.* Berkeley: University of California Press, 1978.

Edgerton, Giles. "Photography as One of the Fine Arts; The Camera Pictures of Alvin Langdon Coburn a Vindication of this Statement." *The Craftsman*, 12, no. 4, July 1907.

Blake, A. H. "The Man and His Aims III: Alvin Langdon Coburn." *The Photographic News*, 52, no. 624, December 13, 1907, pp. 577–578.

[Scott, Dixon]. "The Painters' New Rival: An Interview with Alvin Langdon Coburn." *The Liverpool Courier*, October 31, 1907. Reprinted in *American Photography*, 2, no. 1, January 1908, pp. 13–19.

"Alvin Langdon Coburn." *Camera Work*, 21, January 1908, pp. [3–14], 30–[43]. Illustrated with 12 photogravures.

Reeves, Amber. "The Finding of Pictures: The Work of Alvin Langdon Coburn, Artist." *The Lady's Realm*, 25, no. 148, February 1909, pp. 449–459. Illustrated with 5 halftones.

"London—Twenty Gravures by Coburn." *Camera Work*, 28, October 1909, pp. 50–51; [53–55]. Illustrated with one photogravure.

"Touchstone." "Photographers I Have Met: XIII—Alvin Langdon Coburn." *The Amateur Photographer & Photographic News*, 51, no. 1318, January 4, 1910, p. 9.

"Mr. Coburn's New York Photographs." *The Craftsman*, 19, no. 5, February 1911, pp. 464–468.

D. S., "Magnificent Marksmanship." *The Bookman*, 45, no. 265, October 1913, pp. 44–45.

"Camera Pictures by Coburn. Men of Mark." *Photography*, 36, October 7, 1913, pp. 294–295.

Guest, Anthony. "Mr. A. L. Coburn's Vortographs at the Camera Club." *The Amateur Photographer & Photographic News*, 65, no. 1689, February 12, 1917, p. 107. Reprinted in *Photo-Era*, 38, no. 5, May 1917, pp. 227–228.

"Exhibition by Alvin Langdon Coburn, F. R. P. S." *The Photographic Journal*, 64, n. s. 48, April 1924, pp. 158–159.

"The Coburn Collection: A Munificent Gift." *The Photographic Journal*, 70, n. s. 54, May 1930, pp. 241–242.

Firebaugh, Joseph J. "Coburn: Henry James's Photographer." *American Quarterly*, 7, no. 3, Fall 1955, pp. 215–233.

"Alvin Langdon Coburn." *Contemporary Photographer*, 2, no. 1, Summer, 1961, n. p. Includes the reprint of an essay by George Bernard Shaw from the catalogue of 1906 of the R. P. S. exhibition.

Hall, Norman. "Alvin Langdon Coburn." *Photography*, 16, no. 10, October 1961, pp. 32–41.

Gruber, L. Fritz. "Über einen Fotografen: Alvin Langdon Coburn." *Foto Magazin*, Heft 4, April 1962, pp. 48–51.

Hall, Norman. "Obituary: Alvin Langdon Coburn (Hon. Fellow)." *The Photographic Journal*, 107, no. 2, February 1967, p. 62.

Gruber, L. Fritz. "Abschied von Alvin Langdon Coburn." *Foto Prisma*, Heft 4, April 1967, pp. 180–183.

Contino, V. H. "Fotografia come Scrittura: Alvin Langdon Coburn ed il Vorticismo." *Margutta*, 6, no. 5–6, March–June 1973.

Parson, A. "Alvin Langdon Coburn." *New Boston Review*, 2, no. 2, Fall 1976, pp. 23–24. *The British Journal of Photography*, 126, no. 5, February 2, 1979, pp. 94–97.

Reed, David. "Viewed: Alvin Langdon Coburn at the Camden Arts Center." *The British Journal of Photography*, 125, no. 6152, June 23, 1978, pp. 538–539.

Burgess, Bruce. "Coburn and Vorticism: An Image of the Future." *The British Journal of Photography*, 126, no. 6184, February 2, 1979, pp. 94–97.

Aspin, Roy. "Alvin Langdon Coburn." *The British Journal of Photography*, 129, no. 6358, June 11, 1982, pp. 614–617.

"Alvin Langdon Coburn." *Janet Lehr*, Inc., 6, no. 3, March 1984, pp. 515–544.

Main, William. "Coburn, Hill and Adamson." *History of Photography*, 9, no. 4, October–December 1985, p. 274.

DiFederico, Frank. "Alvin Langdon Coburn and the Genesis of Vortographs." *History of Photography*, 11, no. 4, October–December 1987, pp. 265–296.

Robinson, Keith. "Alvin Langdon Coburn: Photography, Vortography and the Quest for Beauty: ,The Camera is Freed from Reality.'" *ICSAC Cahier*, 8–9, December 1988, pp. 169–178.

Vielledent, Catherine. "Texte et Image: La Collaboration de Henry James et Alvin Langdon Coburn." *Revue Française d'Etudes Américaines*, 14, no. 39, 1989, pp. 29–43.

Schriver, Janet. "Alvin Langdon Coburn: The Silent Bard." *History of Photography*, 17, no. 3, Autumn 1993, pp. 299–301.

Roberts, Pam. "Homage to Alvin Langdon Coburn." *The Photographic Journal*, 133, no. 9, November 1993, pp. 390–393.

Supplementary Bibliography

Johnston, J. Dudley. "Phases in the Development of Pictorial Photography in Britain and America." *The Photo-*

graphic Journal, 63, n. s. 47, December 1923, pp. 568–582.

Doty, Robert M. *Photo Secession: Photography as a Fine Art*. Rochester: George Eastman House, 1960; New York: Dover Publications, 1978.

Gruber, L. Fritz. *Große Photographen unseres Jahrhunderts*. Düsseldorf & Vienna: Econ Verlag, 1964.

Arts Council of Great Britain. *Vorticism and its Allies*. London: Hayward Gallery, 1974.

Cork, Richard. *Vorticism and Abstract Art in The First Machine Age*. London: G. Fraser; Berkeley: University of California Press, 1976.

Arts Council of Great Britain. *Pictorial Photography in Britain 1900–1920*. London: The Council, 1978.

Naef, Weston J. *The Collection of Alfred Stieglitz: Fifty Pioneers of Modern Photography*. New York: Viking Press, 1978.

Jablow, Betsy L. *Illustrated Texts from Dickens to James*. Ph. D. dissertation, Stanford University, 1978.

Harker, Margaret F. *The Linked Ring: The Secession Movement in Photography in Britain, 1892–1910*. London: Heinemann, 1979.

Treasures of the Royal Photographic Society, 1839–1919. Chosen and introduced by Tom Hopkinson. New York: Focal Press, 1980. Royal Photographic Society Publication.

Zinnes, Harriet (ed.). *Ezra Pound and The Visual Arts*. New York: New Directions, 1981.

Pultz, John and Scallen, Catherine B. *Cubism and American Photography, 1910–1930*. Williamstown: Sterling and Francine Clark Institute, 1981.

Taylor, John Russell. "Pictorial Photography in the First World War." *History of Photography*, 6, no. 2, April 1982, pp. 119–141.

Bogardus, Ralph F. "The Photographer's Eye: Henry James and the American Scene." *History of Photography*, 8, no. 3, July–September 1984, pp. 179–196.

Humphreys, R., Alexander, J. and Robinson, P. *Pound's Artists: Ezra Pound and the Visual Arts in London, Paris and Italy*. London: Tate Gallery, 1985.

Sharpe, William. "New York, Night, and Cultural Mythmaking." *Smithsonian Studies in American Art*, 2, no. 3, Fall 1988, pp. 2–21.

Denney, Colleen. "The Role of Subject and Symbol in American Pictorialism." *History of Photography*, 13, no. 2, April–June 1989, pp. 109–128.

Tick, Stanley. "Positives and Negatives: Henry James vs. Photography." *Nineteenth Century Studies*, 7, 1993, pp. 69–101.

Wigoder, Meir Joel. *Curbstone Sketches: Photography, Art and Leisure During the Modern Urban Transformation of New York City, 1890–1920*. Ph. D. dissertation, University of California, Berkeley, 1994.

Pohlmann, Ulrich. "Der Traum von Schönheit: Das Wahre ist schön, das Schöne wahr—Fotografie und Symbolismus, 1890–1914." *Fotogeschichte*, 15, no. 58, 1995.

Hull, Roger. "(With) Holding *Camera Work*." *History of Photography*, 20, no. 4, Winter 1996, pp. 333–334.

List of Plates

*All Photographs were donated
by Alvin Langdon Coburn to
George Eastman House, Rochester,
New York.*

49
Winter Shadows, 1901
Reproduced in:
Camera Work, July 1903
gum-bichromate print
17.9 x 23.6 cm

50
Shadows, 1903
gum-platinum print
19.2 x 23.8 cm

51
The Garden by Moonlight, c. 1911
Reproduced in: H. G. Wells,
*The Door in the Wall and
Other Stories.* London: Grant
Richards, 1911
photogravure print
15.7 x 20.4 cm

52
Sand Dunes, Ipswich 1903
platinum print
18.4 x 23.9 cm

53
The Dragon, Ipswich
c. 1903

Reproduced in:
Camera Work, April 1904
duotone halftone print
13.9 x 17.8 cm

55
The Cloud, 1906
Reproduced in:
H. G. Wells, *The Door in the
Wall and Other Stories*,
London: Grant Richards, 1911
gum-platinum print
40.3 x 31.7 cm

56
Vesuvius, Italy 1905
gum-platinum print
39.7 x 31.9 cm

57
Arch of Titus, Rome 1905
gum-platinum print
35.6 x 28.5 cm

58
The Tiber, Rome 1905
gum-platinum print
29 x 35.9 cm

59
Trevi Fountain, Rome 1905
Reproduced in:
Camera Work, January 1908
gum-platinum print
29 x 36.2 cm

60
Notre Dame, Paris c. 1908
Reproduced in:

Camera Work, January 1908
gum-platinum print
36.3 x 28.8 cm

61
[Paris Rooftops from Notre Dame]
c. 1904
gum-platinum print
43.2 x 23.6 cm

62
Roofs, Paris 1913 / printed later
gelatin-silver print
24.2 x 29.3 cm

63
Roofs, Paris 1913 / printed later
gelatin-silver print
20.8 x 15.4 cm

64
St. Paul's from the River
London c. 1905
Reproduced in: A. L. Coburn.
London. With an introduction by
Hilaire Belloc. London:
Duckworth & Co., 1909
photogravure print
17.8 x 16.4 cm

65
The Tower Bridge, London
c. 1906
Reproduced in: A. L. Coburn,
London. With an introduction by
Hilaire Belloc. London:
Duckworth & Co., 1909
photogravure print
20.2 x 15.5 cm

66
From Westminster Bridge
London c. 1905
Reproduced in: A. L. Coburn,
London. With an introduction by
Hilaire Belloc. London:
Duckworth & Co., 1909
photogravure print
21.2 x 16 cm

67
St. Paul's from Ludgate Hill
London 1905
Reproduced in: A. L. Coburn.
London. With an introduction by
Hilaire Belloc. London:
Duckworth & Co., 1909
photogravure print
38.4 x 28.2 cm

68
Trafalgar Square, London
c. 1907
Reproduced in: A. L. Coburn,
London. With an introduction by
Hilaire Belloc. London:
Duckworth & Co., 1909
photogravure print
21 x 16.2 cm

69
Hyde Park Corner, London
c. 1905
Reproduced in: A. L. Coburn,
London. With an introduction by
Hilaire Belloc. London:
Duckworth & Co., 1909
photogravure print
20.6 x 16.3 cm

70
The British Lion c. 1905
Reproduced in: A. L. Coburn,
London. With an introduction by
Hilaire Belloc. London:
Duckworth & Co., 1909
photogravure print
20 x 16 cm

71
The Embankment, London c. 1911
Reproduced in: H. G. Wells, *The Door
in the Wall and Other Stories*.
London: Grant Richards, 1911
photogravure print
16.8 x 16.2 cm

72
Leicester Square, London c. 1905
Reproduced in: A. L. Coburn,
London. With an introduction by
Hilaire Belloc. London:
Duckworth & Co., 1909
photogravure print
20.1 x 15.6 cm

73
The Temple, London c. 1907
Reproduced in: A. L. Coburn,
London. With an introduction by
Hilaire Belloc, London:
Duckworth & Co., 1909
photogravure print
20.8 x 16.2 cm

74
Waterloo Bridge, London c. 1905
Reproduced in: A. L. Coburn,
London. With an introduction by

Hilaire Belloc. London:
Duckworth & Co., 1909
gum-platinum print
27.8 x 21.9 cm

75
Regent's Canal, London 1904
Reproduced in: A. L. Coburn,
London. With an introduction by
Hilaire Belloc. London:
Duckworth & Co., 1909
photogravure print
21.6 x 17 cm

76
The White Sail, England c. 1908
gum-platinum print
40.7 x 32.2 cm

77
Wapping, London 1904
Reproduced in: A. L. Coburn,
London. With an introduction by
Hilaire Belloc. London:
Duckworth & Co., 1909
gum-platinum print
28.4 x 22.2 cm

78
[Sailboat], c. 1904
gum-platinum print
35.8 x 23.2 cm

79
The Rudder, Liverpool Docks
England c. 1905
Reproduced in: *Camera Work*, 1908
gum-platinum print
36 x 28.6 cm

80
[Coal Country, England] c. 1905
gum-platinum print
33.9 x 41.4 cm

81
The Edge of the Black Country
c. 1911
Reproduced in: H. G. Wells, *The
Door in the Wall and Other Stories*.
London: Grant Richards, 1911
photogravure print
20.1 x 15.9 cm

82
A Tree in Greyfriars Churchyard
Edinburgh 1905
Reproduced in:
Robert Louis Stevenson,
Edinburgh: Picturesque Notes.
London: Rupert Hart-Davis, 1954
gelatin-silver print
39 x 31.4 cm

83
[Two Graves, Wall and Vine] c. 1911
gum-platinum print
45.5 x 34.2 cm

84
Snow in the Grand Canyon, 1911
gum-platinum print
31.8 x 40 cm

85
The Amphitheatre, Grand Canyon
1912
platinum print
32.8 x 41 cm

86
Clouds in the Grand Canyon, 1911
gum-platinum print
41 x 31.8 cm

87
[Grand Canyon] c. 1912
gum-platinum print
40.9 x 31.4 cm

88
From Mount Wilson, Yosemite, 1911
gum-platinum print
28.8 x 39.8 cm

89
Waterfall, Yosemite, 1911
gum-platinum print
40.7 x 33.4 cm

90
Grand Canyon, c. 1911
gum-platinum print
41.1 x 32 cm

91
[Grand Canyon] c. 1911
gum-platinum print
41.2 x 31.95 cm

92
Brooklyn Bridge from a Roof Top
c. 1905
Reproduced in:
A. L. Coburn, *New York*.
With a foreword by H. G. Wells.
London: Duckworth & Co., 1910
photogravure print
19.8 x 14.4 cm

93
The Flat Iron Building, Evening
New York 1912
platinum print
40.5 x 31.4 cm

94
Unfinished Building, New York
1911
platinum print
39.4 x 30.6 cm

95
Fifth Avenue from the St. Regis
New York c. 1905
Reproduced in:
A. L. Coburn, *New York*.
With a foreword by H. G. Wells.
London: Duckworth & Co., 1910
platinum print
40 x 31.6 cm

96
New York from its Pinnacles, 1912
platinum print
41.9 x 32.3 cm

97
The Woolworth Building, c. 1912
platinum print
40.5 x 24.2 cm

98
The Singer Building, New York
c. 1910
Reproduced in A. L. Coburn, *New
York*. With a foreword by H. G. Wells.
London: Duckworth & Co., 1910

platinum print
41.8 x 22.2 cm

99
The Singer Building, New York
c. 1908
Reproduced in:
A. L. Coburn, *New York*.
With a foreword by H. G. Wells.
London: Duckworth & Co., 1910
photogravure print
19.5 x 10.4 cm

100
Times Square (The Christmas Tree)
New York 1912
platinum print
33.1 x 25.3 cm

101
Broadway at Night, New York
c. 1910
Reproduced in:
A. L. Coburn, *New York*.
With a foreword by H. G. Wells.
London: Duckworth & Co., 1910
photogravure print
20.1 x 14.7 cm

102
Trinity Church, New York 1912
platinum print
42.3 x 32.8 cm

103
The Stock Exchange, New York
c. 1905
Reproduced in: A. L. Coburn,

New York. With a foreword by
H. G. Wells. London:
Duckworth & Co., 1910
photogravure print
19.7 x 13.9 cm

104
The Thousand Windows, New York
1912 / printed later
gelatin-silver print
20.7 x 15.7 cm

105
The Octopus, New York
1912 / printed later
Facsimile platinum print
43.6 x 32.5 cm

106
The Waterfront, New York c. 1910
Reproduced in:
A. L. Coburn, *New York*.
With a foreword by H. G. Wells.
London: Duckworth & Co., 1910
duotone halftone print
16.9 x 16.1 cm

107
The Coal Cart, New York 1911
platinum print
40.1 x 30.6 cm

108
The Tunnel Builders, New York
1908
Reproduced in:
A. L. Coburn, *New York*. With a
foreword by H. G. Wells. London:
Duckworth & Co., 1910

gum-platinum print
40.2 x 31.7 cm

109
The Tunnel Builders , New York
c. 1912
gum-platinum print
40.1 x 31.1 cm

110
Station Roofs, Pittsburgh 1910
gelatin-silver print, 19.8 x 28.5 cm

111
Chimneys, Pittsburgh
1910 / printed later
gelatin-silver print
28.2 x 21.3 cm

112
Giant Palm Trees
California Mission 1911
platinum print
40.4 x 31.1 cm

113
Long Beach, California 1911
platinum print
40.4 x 32.9 cm

114
Umbrellas, California c. 1908
gum-platinum print
30.8 x 40.7 cm

115
Niagara Falls, Canada c. 1910
platinum print
40.8 x 30.1 cm

117
[Alligator Fountain] c. 1906
gum-platinum print
45.6 x 34.2 cm

118
The Italian Garden, c. 1907
Reproduced in: Maurice Maeterlinck,
Intelligence of Flowers. New York:
Dodd Mead & Company, 1907
photogravure print
8.6 x 13.7 cm

119
Yew Trees, c. 1913
Reproduced in: A. L. Coburn,
Moor Park, Rickmansworth:
A Series of Photographs.
With an introduction
by Lady Ebury. London:
Elkin Mathews, 1915
photogravure print
9.5 x 12.1 cm

120
A Vista, c. 1913
Reproduced in: A. L. Coburn,
Moor Park, Rickmansworth:
A Series of Photographs.
London: Elkin Mathews, 1915
photogravure print
16 x 12 cm

121
The Temple, The Italian Garden
c. 1915
Reproduced in: A. L. Coburn,
Moor Park, Rickmansworth:
A Series of Photographs.

London: Elkin Mathews, 1915
photogravure print
12 x 15.8 cm

122
[Cascade of Flowers in Urn] c. 1906
Reproduced in: Maurice Maeterlinck,
Intelligence of Flowers. New York:
Dodd Mead & Company, 1907
photogravure print
13.9 x 8.6 cm

123
[Water Lillies] c. 1907
Reproduced in: Maurice Maeterlinck,
Intelligence of Flowers. New York:
Dodd Mead & Company, 1907
photogravure print
13.1 x 9.1 cm

124
The Door in the Wall, c. 1911
Reproduced in: H. G. Wells, *The*
Door in the Wall and Other Stories.
London: Grant Richards, 1911
photogravure print
20.1 x 15.8 cm

125
The Court of the Hotel, 1906
Reproduced in: Henry James,
The Reverberator, Vol. XIII.
New York: Charles Scribners & Sons
gelatin-silver print
29 x 22.8 cm

126
Saltram's Seat, c. 1906
Reproduced in: Henry James,

The Coxson Fund, vol XV.
New York: Charles Scribners & Sons
gelatin-silver print
27.9 x 18 cm

127
The Lord of the Dynamos
c. 1911
Reproduced in:
H. G. Wells, *The Door in the*
Wall and Other Stories.
London: Grant Richards, 1911
photogravure print
20.3 x 16.4 cm

129
Fred Holland Day, c. 1900
gelatin-silver print
19 x 23.8 cm

130
George Bernard Shaw
1904
Reproduced in:
A. L. Coburn, *Men of Mark*.
London: Duckworth & Co., 1913
photogravure print
20.5 x 15.9 cm

131
[George Bernard Shaw] c. 1917
platinum print
26.4 x 10.7 cm

132
[George Bernard Shaw and
Sir James Barrie] 1909
gelatin-silver print
22.6 x 12.3 cm

133
Alfred Stieglitz, 1912
platinum print
22.5 cm (diameter)

134
Henri Matisse, 1913
Reproduced in: A. L. Coburn,
Men of Mark. London:
Duckworth & Co., 1913
photogravure print
18.9 x 15.4 cm

135
Mark Twain, 1908
Reproduced in: A. L. Coburn,
Men of Mark. London:
Duckworth & Co., 1913
photogravure print
20.6 x 14.7 cm

136
Clarence H. White, 1912
Reproduced in:
A. L. Coburn, *Men of Mark*.
London: Duckworth & Co., 1913
photogravure print
20.1 x 15.5 cm

137
[Unidentified Male] c. 1910
gelatin-silver print, 27.8 x 21.6 cm

138
Maurice Maeterlinck, 1915
Reproduced in: A. L. Coburn,
More Men of Mark. London:
Duckworth & Co., 1922
gelatin-silver print, 26.6 x 19.3 cm

139
Herbert George Wells, 1905
Reproduced in: A. L. Coburn,
Men of Mark. London:
Duckworth & Co., 1913
photogravure print
20.2 x 16.1 cm

140
Max Weber, 1911
Reproduced in: A. L. Coburn,
Men of Mark. London:
Duckworth & Co., 1913
photogravure print
20.9 x 14.6 cm

141
Hilaire Belloc, 1908
Reproduced in: A. L. Coburn,
Men of Mark. London:
Duckworth & Co., 1913
photogravure print
20.5 x 16 cm

142
Theodore Roosevelt
The White House, Washington, D.C.
1907
Reproduced in: A. L. Coburn,
Men of Mark. London:
Duckworth & Co., 1913
photogravure print
20 x 16.2 cm

143
William Butler Yeats, 1908
Reproduced in:
A. L. Coburn, *Men of Mark*.
London: Duckworth & Co., 1913

platinum print
27.9 x 22 cm

144
John Masefield, 1913
Reproduced in:
A. L. Coburn, *Men of Mark*.
London: Duckworth & Co., 1913
photogravure print
19.1 x 15.4 cm

145
Oliver Herford, 1905
gelatin-silver print
28.9 x 22.5 cm

146
Henry James, 1906
gelatin-silver print
28.6 x 22.2 cm

147
Henry James, 1906
Reproduced in:
A. L. Coburn,
Men of Mark. London:
Duckworth & Co., 1913
photogravure print
19.9 x 15.8 cm

148
[Augustus John] 1914
gelatin-silver print
26.6 x 23.2 cm

149
Arthur W. Dow, 1903
platinum print
21.5 x 27 cm

150
Auguste Rodin, 1906
Reproduced in:
A. L. Coburn,
Men of Mark. London:
Duckworth & Co., 1913
gelatin-silver print
36.5 x 28.5 cm

151
Gertrude Stein, 1913
platinum print
28.7 x 22.4 cm

152
[Michio Ito, 1916
In W. B. Yeats' play
At the Hawk's Well] 1916
gelatin-silver print
28.1 x 21.7 cm

153
Michio Ito, c. 1916
gelatin-silver print
27.7 x 21.9 cm

154
[Unidentified Chinese
Man ... actor?]
c. 1906
gum-platinum print
37.1 x 32 cm

155
[Unidentified Female
with Bubble Pipe]
c. 1910
gum-platinum print
28.5 x 21.7 cm

156
[Woman with Cape, Wreath, in the
Wind] c. 1913
gum-platinum print
40.6 x 32.2 cm

157
Miss L. R., c. 1909
platinum print
27.7 x 21.7 cm

158
[Unidentified Female] c. 1908
gum-platinum print
28.1 x 22.3 cm

159
[Unidentified Female
on Arm of Chair]
c. 1924
platinum print
28.2 x 22.3 cm

161
Vortograph of Ezra Pound
1917
gelatin-silver print
20.5 x 15.4 cm

162
Vortograph of Ezra Pound, 1917
gelatin-silver print
20.7 x 15.95 cm

163
Vortograph of Ezra Pound
c. 1917
gelatin-silver print
20.4 x 15.4 cm

164
Vortograph, 1917
gelatin-silver print
26.6 x 20.4 cm

165
Vortograph, 1917
gelatin-silver print
28.3 x 20.7 cm

166
Vortograph, 1917
gelatin-silver print
27.2 x 20.6 cm

167
Vortograph, 1917
gelatin-silver print
26.6 x 20.4 cm

168
Liverpool Cathedral
1919
gelatin-silver print
28.3 x 21.3 cm

169
Liverpool Cathedral under
Construction
1919
printed later
gelatin-silver print
28.3 x 21.1 cm

170
Swinside Circle (Cumberland)
c. 1922
gelatin-silver print
15 x 19.7 cm

171
Ty Newydd Llangaelog (Anglesey)
c. 1922
gelatin-silver print
15 x 21.5 cm

172
Bryn Cader Faner
(Hill of Exalted Chair)
Talsarnau c. 1922
gelatin-silver print
15.4 x 19 cm

173
Kemario Alignments (Carnac)
c. 1922
gelatin-silver print
15.5 x 19.7 cm

175
Standing Stone (above Harlech)
c. 1922
gelatin-silver print
19.7 x 14.4 cm

Translation from the German by Rolf Fricke, Gertraud Trivedi and Julian Cooper
Coordination by
Claudia Leiendecker
Editorial direction by
Mirjam Ghisleni-Stemmle
and Nanni Baltzer
Design by
Hans-Georg Pospischil,
Frankfurt (Main), Germany

Printed by
Kündig Druck AG,
Baar-Zug, Switzerland
Bound by
Buchbinderei Burkhardt AG,
Mönchaltorf-Zurich,
Switzerland

Printed on ikonofix special-matt from ZANDERS Feinpapiere AG, Bergisch-Gladbach, Germany

Front cover:
"The Octopus," New York 1912

Back cover:
Portrait of Alvin Langdon Coburn
by Mrs. Fannie E. Coburn.
Grand Canyon, 1911

ISBN 3-908161-33-9